The Tibetan Exercises for Rejuvenation

The Tibetan Exercises for Rejuvenation

Gnosis and the Yantra Yoga for Long Life

Samael Aun Weor

GLORIAN
2008

PUBLISHERS NOTE: When seen in this book, the symbol † indicates additional information available in the Glossary. A more extensive glossary is online at *gnosticteachings.org*

ON THE COVER: Padmasambhava, the Indian Tantric Master

The Tibetan Exercises for Rejuvenation
A Glorian Book / 2008

Originally published in Spanish in "Ejercicios de Lamaseria" (1973).

This Edition © 2008 Glorian Publishing

ISBN 978-1-934206-35-5

Glorian Publishing (formerly Thelema Press) is a non-profit organization delivering to humanity the teachings of Samael Aun Weor. All proceeds go to further the distribution of these books. For more information, visit our website.

gnosticbooks.org
gnosticteachings.org
gnosticradio.org
gnosticschool.org
gnosticstore.org
gnosticvideos.org

Contents

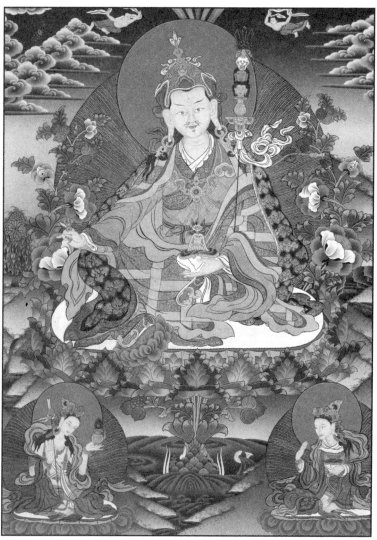

Padmasambhava

Editor's Introduction

The following text is transcribed from oral instructions given by Samael Aun Weor to a student. The transcribed text was initially published by that student in the form of a narrative, and included many personal anecdotes and writings unrelated to Gnosis. In later years, some other Gnostic students decided to publish an edition that removed the extraneous writings and presented the core exercises as a book written by Samael Aun Weor. It should be noted that Samael Aun Weor did not actually write the text, although he did continue to teach and practice the exercises described.

As a curious sidenote, the author of the original book became somewhat known for it, and years later when he attended a Gnostic retreat, Samael Aun Weor asked him to demonstrate the Tibetan exercises in front of all the students. The man replied, "I am sorry, but I do not practice them. I do not know them."

Yantra Yoga

The Sanskrit word "yantra" implies restraint or firm support. In Hinduism, this term is usually used in reference to mystical diagrams or forms utilized in meditation.

The Indian Tantric Master Padmasambhava and his student, a Tibetan scholar and monk named Vairochana, are credited with establishing Buddhism in Tibet (especially Dzogchen) in the eighth century A.D., as well as setting the foundations for Tibetan medicine and a highly sophisticated series of physical and energetic exercises called "Yantra Yoga" (Tibetan: 'khrul 'khor) whose purpose was to establish a strong foundation for spiritual development. Today, these exercises are practiced in many of the schools of Tibetan Buddhism, but kept only amongst the initiated. As Samael Aun Weor writes, some of these exercises have been described publically, but in an incomplete form.

The true **Yantric exercises** have some relationship with both Hatha Yoga (now very popular in the West), Chi Gung, and various martial arts, all of which originated with the intention of keeping the physical body fit enough to withstand the intense demands of spiritual development. Clearly, both Hatha Yoga and the martial arts have largely forgotten their spiritually-focused roots, the evidence of which is their complete inability to awaken the consciousness of their practitioners. The exercises described in this book, however, are very different, and when practiced faithfully, can awaken the consciousness and provide many other essential benefits.

Among the Tibetan Buddhist schools, there are several variations and lineages of Yantra Yoga. The exercises taught in this book are drawn from but not identical to those traditions. As stated in chapter eight:

> "These rites are not the exclusive patrimony of anyone. There are some monasteries in the Himalayas and in other places where these rites are practiced, mainly in a monastery that is called "The Fountain of Youth"...

> "I obtained some data from the mentioned monastery, which I know very well, and other data from other schools in India that I also know very well."

Terminology

These exercises have been known by various names, notably called by Gnostic students "the Tibetan rites" or "the lamasery exercises." It is important to note that the term "lamasery" did not originate in Asia, but was invented by Westerners. Samael Aun Weor used the term as was conventional at the time he was teaching. However, in the spirit of continual improvement that he followed, and with respect to the tradition from which these exercises are derived, we prefer not to perpetuate the use of the term. Therefore, in this book we have exchanged the misnomer "lamasery" for the more accurate and appropriate term "monastery." Furthermore, we also suggest referring to the exercises with the name of the tradition to which they belong: Yantra Yoga. We the Editors have made those changes to this text.

Prologue

During the moments in which I write this prologue, before my sight within this park of the city of Mexico D.F., I observe some people seated on benches contemplating the beauties of nature: beautiful trees, gorgeous fields, and some children playing in the warm rays of the sun.

Many scenes emerge from within my memory... dramas, extraordinary events from ancient times, like: initiatic colleges, solitary hermitages, where, amidst singing rivulets running precipitately along their bed of rocks, the anchorites meditated in silence; marvelous Sibyls from the druids of Europe; and from primeval times, the hermits of the ancient Egypt of the Pharaohs, etc.

There is no doubt, brothers and sisters, that in those times of yore, within the mysteries of Eleusis, Troy, Rome, Carthage, Egypt, etc., the psychological and the physical were marching in a harmonious, perfect, parallel way.

For instance, in these moments I remember the Pythagorean Mysteries to which, in ancient times, those who lacked mathematical knowledge were not admitted.

Remember the whirling dervishes, the magnificent runes, the beautiful dances of India, the perfect rhythmical movements of the Egyptian Initiates: in them all you will see, brothers and sisters, the extraordinary parallel which always has existed between the spiritual, the psychological, and the physical.

Indubitably, we have a body of bones and flesh; such a body possesses a marvelous eurhythmy, and many powers that must be awakened are latent within the brain. Thus, it is indispensable to learn how to handle our body, to know how to take, to extract, the sweetest melodies from it. It is important to make it to vibrate as a symphony of the miraculous harp of the universe.

It is absurd, beloved brethren of mine, to allow Heropass (time) to damage this precious physical vehicle, which has been granted unto us for the realization of our own Inner Self. Ver-

ily, I tell you, brothers and sisters, that we, the Gnostics, have precise methods in order to rejuvenate the organism and cure all sicknesses. It is unquestionable that we can learn how to heal ourselves. Each one of us can be converted into our own physician by learning how to heal ourselves without the necessity of "medicine" - lo and behold, the most beloved ideal.

It is urgent to preserve the physical body in perfect health for many years so that we can use this precious physical vehicle for the realization of our own Inner Self.

Here we deliver the necessary exercises for the preservation of health and for the prolongation of life. Here you have, brothers and sisters, the precious methods by means of which you (if you are old) can re-conquer youth, and if you are young, can prolong such youth in an indefinite manner.

Therefore, understand by reading with attention, and then practice. It would be worthless for you to just theorize, thus it is necessary to go to the point, straight to the facts, because this is simultaneously an eminently practical and didactical book.

These teachings are delivered in a dialectical way. However, I repeat, do not become content only with bookish information: transform the doctrine into facts, because the teachings that we deliver in this book are also for the awakening of the consciousness. Yes, the hour, the moment, for the awakening of the consciousness has arrived; why should we continue with our consciousness asleep, when the one hundred percent efficient and absolutely practical procedures for awakening are delivered in this book?

Thus, if each one of the devotees practices meditation in the manner that we have taught, they will then, any day, reach Samadhi.

Now, with the precise didactical and practical exercises given, any sincere aspirant can provoke the great permutation, that is, the authentic, radical transformation.

First of all, what is indeed most essential is to have a continuity of purpose: it is not enough to practice today, and forget about it tomorrow. Thus, it is necessary to practice and to

practice intensely for our entire life until reaching the goal: the ultimate triumph.

May peace be with all of humanity.

Samael Aun Weor

THE FLOOD THAT DESTROYED ATLANTIS IS RECORDED IN ALL THE WORLD'S HISTORIES.

Chapter 1
Reflection

Brothers and sisters, let us reflect; I want to tell you in the name of the cosmic truth, in the name of that which is reality, that the necessity of dying from moment to moment exists, because that which is new only arrives through death.

Someone whose name I do not mention, who is indeed a very famous author, stated that perhaps a Golden Age will begin for the world in the year 2007. Obviously, it seems to me that such a statement is absurd. From where are we going to get the elements for such a Golden Age? From all of those egos, from the bestial "I," from all of those psychological egos which are incessantly returning? Obviously not; this is why it seems to me that such a statement is impossible and absurd.

Indeed, so long as we do not die psychologically within ourselves, an age of light and glory is impossible. How can peace reign over the face of the earth if the elements that produce war are carried within each one of us? How can love reign over the face of the earth if hatred subsists within each one of us? From where can altruism arise if egotism is what we, unfortunately, carry within the depth of our consciousness? How can chastity become resplendent over the face of the earth if lust exists within the depths of each one of us?

Unquestionably, beloved brethren of mine, it is impossible to create an age of light under these aforementioned circumstances, because the ego can never create an age of light. Therefore, any prophecy based on this sensibility seems to me to be absolutely false. Obviously, we must psychologically die from moment to moment; because only in this way can the light emerge.

What about the multitudes? If the egos of the social crowds are very alive, if their egos return incessantly, if they constantly arrive to be born in this valley of Samsara, then how are we going to develop such a Golden Age? Who would edify it? Would a Golden Age be edified by Satan, the myself, the self-willed,

the pluralized "I," the egos of the multitudes? So, brothers and sisters, let us reflect profoundly.

Prophecy about Hercolubus and the Impending Doom

Obviously, we are at the eve of a great cosmic cataclysm, this is indubitable. Scientists already know that a world called the Red Planet is approaching the orbit of our planet Earth; yes, a planet is approaching, and the scientists want to push it away by means of nuclear explosions: nonetheless, everything will be useless. Thus, the moment will arrive in which all of the prophecies have to be fulfilled.

Mohammed already spoke clearly about an earthquake, which is the great event known since the beginning of the centuries that must come to pass. The Koran Sura 56 textually states: "Then the mountains shall be made to crumble with (an awful) crumbling, so that they shall be as scattered dust." This invites us to reflect...

This prophecy would remain impossible if there was no earthquake; yet, how could this earthquake come to pass? Indubitably, such an event will come to pass by means of a collision of worlds, and this is precisely what is going to happen, my beloved brothers and sisters. The book of Revelation (Apocalypse) also states to us about an earthquake:

> And there was a great earthquake, such as was not since men were upon the earth, so mighty an earthquake, and so great.
> - Revelation 16:18

Therefore, I want you to have an in-depth reflection upon the moment in which we presently are. Indeed, we live in a difficult epoch; we are in the times of the end, or as the Apocalypse, the Revelation of Saint John states, in the beginning of the end of the era of the gentiles.

The ancient land Atlantis perished by the water, yet our present land will be burned with fire. In chapter three of his second epistle, Peter also stated very clear about this as follows: "And the elements shall melt with fervent heat, the earth also and the works that are therein shall be burned up." Yes, beloved

brethren of mine, this is true: the elements shall melt with fervent heat. Thus, reflect: delve within this. Indeed, what I am speaking about has a tragic appearance; yes it is true, and this is because I do not want to fail to take advantage of this opportunity, not even for a moment, so that I can call your attention, because it is necessary for you to live in a state of alertness; yes, especially in these very difficult times.

Within the world of natural causes I perceived the future that is reserved for our planet Earth. What I saw was indeed frightful: the twelve constellations of the zodiac appeared in a symbolical, pictorial, or allegorical way as twelve terrible, mighty giants, who—threateningly—were blustering forth lightning and thunder. It seemed as if the doom, the final catastrophe, was happening in those moments. I was also aware, beloved brothers and sisters, that the inhabitants from other planets do not ignore this impending doom: they are preparing themselves for the event. Yes, you can be sure that on that day and hour, cosmic ships from other worlds or planets will take - we would say - certain kinds of photographs (using in this case our terrestrial terms related with the photographing or imprinting of images) imprinted over some type of plaques or something of the sort, with the purpose of storing the memories within their archives, memories related with a world called planet Earth, whose humanity has been sentenced because of their evilness: a terribly perverse humanity.

On another occasion, I was conversing with my Divine Mother Kundalini. She said to me, "Everything is already lost. The evil of this world is so great that it even reached the heavens. Babylon the Great, the mother of all fornications and abominations of the earth, will be destroyed, and from this perverse generation of vipers nothing will remain, not even one stone upon another."

Astonished, I said, "Oh mother of mine, are we found to be within a dead-end street?"

The Adorable One answered, "Do you want to make a negotiation with me?"

I answered, "Of course, I do."

"Then open an escape from this dead-end street," She continued, saying, "and I will kill them."

Thus, brethren of mine, opening the dead-end street: this is what we are doing; yes, we are in these moments organizing a world rescue army. Joyful will be those who know how to take advantage of the opening in the street, because I want you to know in a concrete, clear, and definitive manner, that all of this that you presently see in the world will be destroyed.

When the already mentioned planet that is traveling towards the orbit of our world, towards our planet Earth, comes closer, obviously it will burn with its radiations everything wherein there is life. Then, the liquid fire from the interior of the earth, by means of the compelling approach of this planet, will be magnetically attracted, and erupting volcanoes will emerge everywhere; this will unleash frightful earthquakes never seen or sensed in the past: thus, lava and ashes will be everywhere.

The sacred scriptures state that in those days the sun will darken and will not give its light. Obviously, brethren of mine, such a traveling planet, which is going to collide with our terrestrial world, will interpose itself between the resplendent sun that illuminates us and our afflicted world.

Then, a very thick darkness will spread out, where painful woes amongst the terrible telluric movements will be heard; the temperature will rise frightfully, and the people will flee here, there, over there, and everywhere, yet to no avail, since indeed, humanity will not find escape anywhere.

Finally, the stored hydrogen of our planet Earth will become ignited, thus burning everything in a striking holocaust in the middle of the infinite space. Therefore, brethren, when that world that is approaching to collide with our planet comes closer, death with its scythe will reap millions and millions of lives. When the merely physical magnetic collision happens, there will not be anyone alive. Indeed, who would be capable of enduring it? Thus, this is how, beloved brothers and sisters, a perverse civilization will end; this is how this wicked civilization will succumb.

That which I am now stating may seem to be something exotic and strange; yet, the Atlanteans felt likewise in those days before the Universal Flood. Yes, before the waters swallowed that humanity, many of them laughed about it. Rare were the ones who listened to the Manu Vaisvasvata, the authentic biblical Noah, who took the selected, chosen ones, the world rescue army, from the dangerous zone and guided them to the central plateau of Asia, by passing through where there was dry land.

Then, the perverse ones, the black magicians, the Baalim with tenebrous countenances, died in desperation.

Today, brethren, we are speaking as we did in Atlantis. Today, I am prophesying as I prophesied then in that now submerged continent. Now, I am warning as I warned in that epoch. However, there is only one difference: at that time, the Atlantis-Earth - with everything that was within it - perished by the water, yet now our present Earth will succumb to fire. Therefore, beloved brethren of mine, after the great cataclysm, only a great chaos of fire and water vapor will remain.

Earth will be desolated; however, the select chosen will be taken from the dangerous zone and taken to other worlds; thereafter, when the surface of the Earth has the proper conditions to have human seed anew, then those who have been taken and crossed with the races of other worlds of the infinite space will return in order to populate the transformed face of the Earth, the Earth of tomorrow, the New Jerusalem spoken of by the Apocalypse, the Revelation of Saint John.

Remember that there will be a new Heaven and a new Earth: on this, all the prophets agree. It is precisely on that new Earth where the glorious esoteric civilizations of the past will resurrect. The great Sixth Root Race of the future will be a mixture of terrestrial human seed with the best of the human seed from other planets.

Therefore, I want you to comprehend that the resurrection of past civilizations will be a concrete fact. In the first subrace of the future great Sixth Root Race will resuscitate once again that culture, that esoteric civilization, that as a result of the

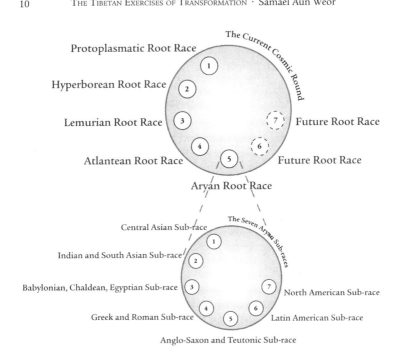

Protoplasmatic Root Race
Hyperborean Root Race
Lemurian Root Race
Atlantean Root Race
The Current Cosmic Round
Future Root Race
Future Root Race
Aryan Root Race

Central Asian Sub-race
Indian and South Asian Sub-race
Babylonian, Chaldean, Egyptian Sub-race
Greek and Roman Sub-race
The Seven Aryan Sub-races
North American Sub-race
Latin American Sub-race
Anglo-Saxon and Teutonic Sub-race

submerging of Atlantis flourished on the central plateau of Asia in the first age of our Fifth Root Race.

Then, the second subrace of that future Sixth Root Race will also be grandiose, because we will see the resurrection of those powerful cultures that flourished in the south of Asia: the pre-Vedic culture with the wisdom of the Rishis, with its great sacred elephant processions, from those ancient Hindustani times, etc.

The third subrace of that future Sixth Root Race, there in that transformed Earth of tomorrow, will also resuscitate; yes, the powerful Egyptian civilization will emerge again. Then there will be a new Nile, new pyramids and new sphinxes, and millions of Egyptian souls will again return, will reincarnate, in order to make the Neptunian-Amentian wisdom resplendent again upon the face of the earth, with its entire splendor and brightness.

In the fourth subrace of that future Sixth Root Race, on the new Earth of the future, the Greco-Roman culture will again

emerge with its entire power, along with the mysteries of Eleusis, with the sacred mysteries of ancient Rome, etc.

Then, a fifth subrace within which the Anglo-Saxon and Teutonic civilizations will appear, yet in a very much elevated manner, much more spiritual. Nonetheless, it cannot be avoided that some failures will exist in that epoch; yes, they will exist, this is clear.

In the sixth subrace will appear a culture very similar to the subrace that populates the Iberoamerican continent, yet, I repeat, this will be in an octave of superior order to its former appearance.

Finally, in the seventh subrace of that future Sixth Root Race, on that new transformed Earth of the future, with new heaven and new seas, a culture will flourish that will be very similar to the one which exists presently in the United States of America, yet it will be immensely more spiritual; nonetheless, new and more failures cannot be avoided.

Thereafter, in the end, beloved brethren, another great catastrophe will come, that in that epoch will be caused by the water. Thus, at the end of times, a final continent will emerge, the last continent where the Seven Root Race will flourish.

So, right now, I limit myself to remind you that we are warning of a great impending cataclysm that is approaching, so that the ones who want to enter the ranks of the world rescue army can join us.

Those who follow the esotericism, the ancient wisdom, will be taken from the dangerous zone in the precise, appropriate moment, as indicated by the Great Law. Those who do not follow the esotericism, the ancient wisdom, those who do not accept the teachings, those who reject Gnosticism, will unquestionably perish.

So, an extraordinary event will occur, something very similar to what I already stated, as what happened in ancient times when the Atlantean continent was destroyed.

The powerful civilization of the future, the Golden Age, the Age of Light and Splendor, will only emerge after the great impending doom. Presently, a Golden Age is impossible, simply

because the ego cannot create divine cultures; the ego is incapable of bringing the ancient, esoteric, spiritual civilizations to resurrection.

Therefore, those who prophesized, those who stated that in the year 2007 an age of splendors and light will be initiated, are completely mistaken. Understand, in the name of the truth, that such an age can be only built by the Being, by that which is divine, by that which is the most decent within the most profound part of our consciousness, and never by the myself or the self-willed ego.

I want you, Gnostic brothers and sisters, to be prepared; I advise you to dissolve the ego; you must die within yourselves, you must eliminate your self-willed ego.

Only the Being can originate powerful civilizations of light. Only those who have died within themselves can become victorious in the impending hour. Only those will not enter into the abyss; only those can live in the Age of Gold without the need to pass through the Second Death.

In my book entitled *The Mystery of the Golden Blossom*, I taught how to use the lance. It is necessary to know how to use the Lance of Longinus, the weapon of Eros, so that you can destroy all of those psychic aggregates that constitute the ego, the myself, the self-willed. Indubitably, we can perform marvels in the forge of the Cyclops; it is there where we can create the Soma Psuchikon, in other words, the wedding garment of the soul.

It is also there where we can handle that marvelous weapon, the weapon of Eros, with which it is possible to destroy those psychic aggregates that constitute the self-willed ego. Thus, when the entire ego has been radically eliminated, then only the Being, the Divine, that which is perfection, will remain within our interior.

Believe me, my beloved brothers and sisters, it is the ego that makes us ugly in the most complete sense of the word. Yes, those who carry the ego within, indubitably radiate leftist, sinister, tenebrous, and abominable waves. So, when the death of the myself has been performed within, then only beauty re-

mains within the profound interior of each one of us, and from that beauty emanates that which is called love.

How can we sincerely irradiate love if we carry the ego within? Thus, it is necessary for our ego to be destroyed so that only love remains within us. Hermes Trismesgistus said: "I give thee love within which the entire summum of wisdom is contained."

To love; that is what is fundamental. Love makes us true sages in every aspect of existence, since this is indeed the summum of wisdom.

Authentic wisdom does not pertain to the mind but to the Being; it is a functionalism of the consciousness, a glorious synthesis of that which is called love, because love is the summum of all science, all true and real knowledge.

Beloved brethren, the mind does not know the truth, it is bottled up within the ego, it does not know anything about reality. Let us destroy the ego, let us liberate ourselves from the mind so that the truth, that which is the Being, reality, can remain within us.

In *The Mystery of the Golden Blossom*, I taught how to handle that extraordinary weapon, which is the lance; I now repeat this statement with the sincere intention that you learn how to handle it in a precise manner and in this way destroy each one of the psychological aggregates that constitute the pluralized "I", the ego, the myself, the self-willed.

Precisely, it is in the forge of the Cyclops where we must invoke Devi Kundalini, our divine, particular, cosmic Mother, so she can eliminate this or that physiological defect with the lance; in other words, with Her weapon She can eliminate this or that psychological aggregate, this or that error, this or that "I." Obviously, She will do it with her weapon; this is how we will die from instant to instant, from moment to moment

It is not enough to comprehend a defect: it is necessary to eliminate it. Comprehension is not enough; elimination is necessary. We can label a defect with a different name, pass it from one to another department of the mind, etc, yet we can never

fundamentally alter it. For this, we need a power superior to the mind, a power capable of eliminating this or that error.

Fortunately, such a power is found in a latent state within each one of us; obviously, I am referring to Devi Kundalini, the igneous serpent of our magical powers. Thus, only by beseeching Her can She eliminate the defect that we have integrally comprehended.

Thus, by dying from moment to moment as we already indicated, the delectable moment will arrive within which only the Divine, the perfection, the Being, that which is the reality, abides within us.

Those who want to fill the ranks of the future civilization, those who presently do not want to descend into the submerged devolution within the entrails of the earth, must dissolve their ego now. We are therefore facing a dilemma: whether we dissolve the ego by means of our own whim, by our own will, or have hell dissolve it for us.

If we resolve to not dissolve it, if we do not want to disintegrate it, then nature will take care of it in the infernal worlds, within the infradimensions of the cosmos, within the living entrails of this planet on which we live. Alas, in what conditions? It will be through infinite bitterness, through unending sufferings, and frightful agonies, which are impossible to describe with words.

Therefore, reflect: I invite you to very minutely reflect upon this aspect and thereafter to die within yourselves; comprehend my words, since for some or many, this may be their last opportunity.

Chapter 2

Gnostic Paladins

In order to form the Gnostic Movement, I have fought very much here in Mexico during the eighteen years of a continuous journey towards a permanent diffusion of the Gnostic teachings.

Thus, after this rigorous work, I have achieved the preparation of a group of paladins who are ready to make a gigantic movement that will extend from border to border and from one sea to the other; in other words, from the border of Guatemala to the border of the United States and from the Atlantic ocean to the Pacific ocean.

All of this has been a matter of intense work, of an unwearied battle. Now, we have various organized groups, so the basis for the gigantic work that awaits us is established, thus in a short time, the Gnostic Movement here in Mexico will be powerful and organized according to the law.

We have many people in the First Chamber; yes, many aspirants attend the different groups of First Chamber. However, the aspirants within the Second Chamber are fewer, and this is because they require better preparation. Concerning this stage of the teachings (Second Chamber) I am more careful; thus, in order to pass a student into the Second Chamber, I have to be very sure that such an aspirant is completely defined, since it is clear that in the Second Chamber many esoteric aspects of great responsibility enter into action, and it is clear that a great deal of veneration, respect, and responsibility is demanded from the student. The student must enter into the Second Chamber duly prepared in order to appreciate the esoteric value of this chamber. I could not authorize the entrance of individuals that are not completely defined, because this will be absurd; thus, for such cause, I delay very much before passing someone to the Second Chamber. Sometimes I allow them to enter after one or two years, nonetheless, since there are some individuals who do

not give the keynote that is needed in order to pass them into the Second Chamber, then I delay them for even three years.

Now the students of Third Chamber, indeed, are very few, because these have to be very well defined. So, the Third Chamber is active here in Mexico in a very special place. I want you to emphatically know that the Third Chamber has only one objective: the awakening of the consciousness. Here, we, with effective and practical methods which I already taught, dedicate ourselves as a group to the awakening of the consciousness.

Thus, in the Third Chamber we have individuals that are already working in the Jinn state, who work perfectly in the fourth dimension; some of these students have gone to Tibet with their body of bones and flesh in the Jinn state. Of course, these are people of Third Chamber that work intensely with concentration, meditation, and Samadhi, etc. So, the students of Third Chamber are awakening very fast because they are increasingly working in a practical way, i.e. with astral projection, in the Jinn state, in ecstasy; thus, I am not content until they become totally awakened.

Here in Mexico, I have told the students of Third Chamber that the moment will arrive in which we will only reunite in the Jinn state; therefore those who are not prepared to attend with their body in the Jinn state will remain out of the Third Chamber. Thus, many of them are struggling, yet others are very happy because they already achieved their purpose. This is what is essential: to intensely work with these practices.

Thus, the time will arrive in which the students have to come in Jinn state, because those who do not come in the Jinn state will not be admitted into the third chamber.

It is remarkable to notice the way in which my real Being lifted me up with a lot of strength; he did not leave me alone, not even for a minute; i.e. I just laid down in my bed, when there, in that very moment, he would take me within my Astral Body out of my physical body. Yes, my real Inner Being desperately fought and fought in order to lift me up from the mud of the earth. So, he did not leave me quiet not even for a second, until the day in which I returned to the real Path.

When one reads *The Divine Comedy* of Dante Alighieri, one starts by seeing how he is descending into the inferno; Dante states: "Halfway through the journey we are living I found myself deep in a darkened forest..." and I state the same... it is clear that I was a fallen bodhisattva; nevertheless, my real Being returned me to the straight path and through it he lifted me up. Now I am standing on my feet again.

So, when the Real Being wants to lift one up, he performs supreme efforts in order to do it, and he does it. Now, thanks to God, we are already fighting, working under the commands of the Father. Here we go, little by little. What is important is for the people to receive the teachings, that everybody receives the message, and that they take advantage of it. This is what is important.

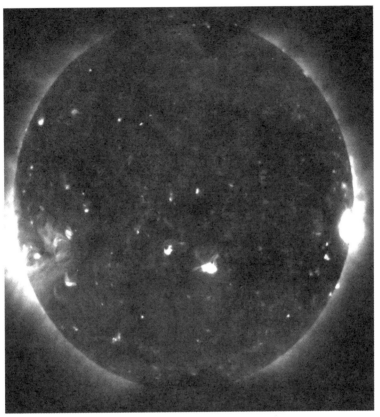

PHOTOGRAPH OF THE SUN BY NASA

Chapter 3
The Inhabitants of the Sun

Common and ordinary people believe that the Sun is a ball of incandescent fire, yet such a concept is mistaken. Yes, it is a false concept, rooted in a completely medieval way of thinking: i.e., in the middle Ages, people believed that the Sun that illuminates us is a ball of fire. This is just a mistaken way that people think, so what can we do: this is how humanity is.

Some scientist somewhere supposed that the Sun is a cloud of helium in an incandescent state; yet if this is true, the planets of the solar system would have left their orbits and would have never gravitated around the sun. So, the fact that these celestial spheres gravitate around this luminous center indicates to us with complete meridian clarity that this is related with a solid physical sun. Therefore, the scientist who affirms that the sun is a cloud of helium and that it does not have weight, based on his mistaken calculations, indubitably, is a learned ignoramus.

I ask myself: Why do the planets gravitate around the sun? Upon what basis—nuclear or gravitational center—is the planetary system supported? The very fact that the planets gravitate around this star indicates to us that such a world, such a star named "the Sun," weighs more than all of the planets of the solar system together. Only in this way can we explain to ourselves how the planets gravitate around sun, even if this fact is not understood by these present men of science.

We, the esotericists, have marvelous instruments for investigating life in the superior worlds. The Astral Body, the Eidolon, allow us to travel from one planet to another; i. e., with this vehicle named Eidolon, Astral Body or sidereal body, I have transported myself many times to our king star (the Sun), therefore I know it very well. I know indeed in which way it functions, what it is made of, what its surface is like, and what is found in the Sun. Therefore, I can tell you that the Sun is a gigantic, enormous world, many millions of times bigger than the planet Earth or the planet Jupiter. The sun has rich mineral, plant,

animal, and human life, very elevated mountains, north and south poles covered with ice, as well as enormous and profound seas, extraordinary jungles, etc.

Even if this seems incredible, the fact is that there are places on the Sun where one can die because of the cold temperatures, such as immense, snow-covered mountains with extremely cold weather. However, very pleasant tropical, warm weather also exists; the coasts, for instance, are very hot, since these are at the foot of its seas; this is obvious.

Therefore, all types of weather exist on the Sun. The inhabitants of the Sun never live in cities: they consider the making of cities absurd, and we agree with them, since life in the cities is indeed harmful and extremely detrimental. Within the cities, we human beings live climbing upon one another within buildings of many floors, or we live in houses stuck to another and within the smoke of factories and automobiles. We live slithering against one another, hurting each other in an involuntary or voluntary manner, etc. For such reasons, the inhabitants of the Sun would never commit the recklessness of living within cities.* Thus, they do not like cities, and even though they normally live in wooded lands, they nonetheless have small villages where they perform their scientific investigations.

Once, when I traveled there with my sidereal vehicle or Astral Body, I was conversing with a group of solar sages, who very harmoniously hosted me. What is astonishing about this experience is that even though I was present among them within my Astral or sidereal body, they could see me and hear me. Undoubtedly, in those moments they were acting within their bodies of bones and flesh, yet they saw me as if I was also there in a physical body; this demonstrates that they possess the extraordinary faculties of clairvoyance, clairaudience, etc.

Yes, we conversed while seated before a beautiful table; suddenly, they excused themselves, because that was the precise moment suitable to enter into their observatory. I saw them looking through some lenses while making enormous and complicated mathematical calculations. During those days, they were very concerned with a very distant system of worlds,

which was situated many millions of light years away, very much distant from the solar world where they live.

They were very concerned with thoroughly investigating that system of worlds. Thus, at that time they were planning an expedition to those very distant worlds. It is evident that the inhabitants of our Sun possess marvelous cosmic ships that can travel throughout space, so they were carefully mapping out the route and making the necessary calculations in order to reach that mentioned system of worlds with precision. Thus, they were in those days very concerned in recognizing the exact route.

Frankly, I was astounded, since the telescopes that they possess are extraordinary. Esoterically speaking, we can call those telescopes "Teskooanos"—a very exotic term, isn't that so? Teskooanos.

It is very astounding for all of you to know that there are inhabitants in the Sun, isn't that so? Well, you must also know that with their telescopes they can see the planet Earth, and any other planet of this solar system. They can see not only our world, but moreover, they can see its cities and the houses that we have on this planet Earth; they can see the people who live in each house that they want to investigate, and they can see them not only from the physical point of view, but also from the esoteric or occult aspect; yes, they can clearly see the aura of people and the psychological state in which any given person is found, etc.

Therefore, they do not ignore the disastrous state in which our planet Earth is. They express grief because of the state in which we are found; they want the best for our world... Regrettably, we have to acknowledge that our planet Earth's humanity has completely failed. So, in no way do they want to establish any type of relation with people who possess ego, the psychological "I," the "my-self," the self-willed, the legion.

The solar inhabitants come only into contact with "very dead" people. When I am talking in this way, when I say "very dead people," I want you to understand that I am not talking about physical death: instead, I am emphatically referring to the

death of the ego. So when I say, "very dead," I want you to understand that they only want to come into contact with persons who already have disintegrated their ego, persons who already have psychologically died within themselves, within their self-willed ego; in other words, they only come into contact with people who do not have ego, who do not have the "I," who have freed themselves from the ego.

Indeed, regarding this subject matter, they are right. I completely agree with them, because those who possess ego, those who still have ego, emit sinister, fatal, diabolic, perverse vibrations; and people in this fashion introduce disorder wherever they go. Such a type of people, who have such egotistic, diabolic conditions, could never live in harmony with the infinite. Thus, for such cause they do not want to have any type of - we would say - personal relations with individuals or people who have not have psychologically died within themselves, who have not dissolved their ego, their "I."

Into my memory come some very beautiful landscapes of the Sun... On the sun there exists a sea so deep, so gigantic, with very clear and beautiful waters that astounded me... Many times in my Astral Body I navigated it on a small ferry, thereafter reaching a certain bay where I have reposed for hours. It is clear that in the Astral plane one can navigate in some boats; naturally, these are made of astral matter. Additionally, one can navigate within any, we would say, physical vessel... Thus, anyone who know how to travel in their Astral Body can do the same thing, this is clear. What one needs is to become cognizant, because the sleepy ones could never do these things. So, this bay seems very beautiful to me.

Such a sea is millions of times bigger than the entire planet Earth; I can asseverate to you that if we place all of the seven seas of the planet Earth within that sea, it would be as if pouring a glass of water into that big ocean. Think to yourself the significance of the size of such a big ocean, since any of our oceans, those which we have on our planet, are nothing but little puddles when compared with that immense sea of the Sun to which I am referring. Every once in a while, I saw certain marine monsters emerging on the surface of that sea; they

watched the horizon and submerged themselves again within the immeasurable depths of that solar sea.

Nevertheless, for the Earthlings all of this is inconceivable, since people of this day and age think that the Sun is a ball of fire and there is no one capable of removing that nonsensical idea from their head.

When the Sun is seen from the Astral point of view, it is extraordinary. For example, a secret path exists that leads to heart temple of the Sun; of course, it is not related with a physical path, and I want all of you to understand this. The secret path that I am referring to is Astral, esoteric. As I already said, it leads to the heart temple of the Sun. It is a path that does not belong to dense matter, since when one approaches to see it on the surface, the only thing that one perceives is the great profundity of a tenebrous abyss, yet some blazing flames are seen there in its ignote unfathomable depths.

In my Astral vehicle, I have descended into such a precipice, I have reached those blazing flames. There, one is blessed by a great Being, who is the doorman or guardian of the temple; he blesses us with an olive branch. Thereafter, one continues by a secret path that goes to the heart temple of the Sun.

In the heart temple of the Sun, one finds the seven Chohans, seven great Beings who work in this solar system. There, one feels the flux and reflux of the great Life: this is the systole and diastole of the entire cosmic system in which we live, move, and have our Being. It can be said that there throbs the heart of the Sun, the heart of the solar system. Seen from afar, the solar system looks like a being walking throughout the inalterable infinite space, since it has functional organs; i.e., Mars is the liver of the solar system, and the Sun - properly said - is the heart, yet, one must search for such a heart within the very nucleus of that central mass.

Incidentally, the most powerful ray of the Sun vibrates at dawn and belongs to the Kundalini. Thus, this is why it is interesting and even very advisable to practice Sahaja Maithuna at dawn, at the dawning of the day.

As different elementals of nature exist in every planet, likewise they also exist in the Sun, where life flows and reflows with an incessant beauty.

Scientists suppose that the Sun is a ball of fire or a cloud of helium or something of the sort. Common and ordinary people think that the Sun is like a huge bonfire, which the closer one gets to it, the more is one exposed to become burned; regretfully, this is a misconception. If you climb high to the peak of a 5000 meter mountain, you might die of cold there; likewise, if you elevate yourself to the stratosphere in an aerostatic globe, you might also die there because of the cold temperature. In interplanetary space, temperatures reach 120 degrees below zero (Celsius).

Therefore, the idea of regarding the Sun as a ball of fire is false. The Sun is a world, extremely rich in uranium, radium, cobalt, etc., lodes, thus, since it is so immense, it is clear that the radiation of its lodes is also extremely strong, very powerful. The sum total of the radiation of its lodes produces tremendous irradiations; thus, the radiations of its lodes, the entire atomic energy that these possess, traverses the interplanetary space and arrives to the terrestrial atmosphere, which decompose the radiations into light, heat, color, and sound.

Yes, it is precisely the superior cap of the terrestrial atmosphere that is in charge of analyzing and disarranging the solar rays into light, heat, color, and sound; notwithstanding, as I already said, there is an intense cold in the interplanetary space whose temperature reaches 120 degrees below zero (Celsius).

Therefore, the Sun is not a ball of fire as the common and ordinary people suppose and as some scientists presume, but a gigantic world rich in lodes, whose radiations - when disarranged in the atmosphere of the Earth - are converted or become light, heat, color, and sound. The radiation of the Sun reaches not only the planet Earth, but all of the planets of our solar system, thus the atmosphere of each planet analyzes and disarranges the solar rays into light, heat, color, and sound.

After this explanation, it is convenient to remove from our minds once and for all those false ideas, and to understand that the Sun is not a ball of fire.

Yes, many astronomers entertain themselves when studying the aureole of the Sun or the corolla of the Sun, thus they think that such a corolla must be physical, material, a dense mass, yet theirs is a misconception. The corolla of the Sun is a kind of aurora borealis formed by the electricity and magnetism of such a star, and that is all.

The inhabitants of the Sun are people whose bodies have a stature more or less similar to the human beings of the Earth; yes, the people of the Sun are of a size like the people of the Earth, yet their bodies are harmoniously perfect, very beautiful; men and women live in an insuperable state of harmony.

QUESTION: Master, if the Earth did not have atmosphere, would our planet be a world in darkness?

ANSWER: If there were not any type of atmosphere on the Earth, then this would be a world in darkness. Yet, in this case, it could be objected that there is no atmosphere on the moon and yet there are times when there is light and times when there is darkness, or the moon has, we would say, half light and the other half in obscurity; in other words, the lunar month is divided into periods of light and periods of obscurity according with the cosmic periods that already are known in depth and that the astronauts have utilized for their expeditions. Anyway, it has already been officially accepted that the moon has an atmosphere and that even being rarefied, incipient, it can nonetheless perfectly disarrange the solar rays into light, heat, color, and sound.

Thus, in the case of there being no atmosphere on the planet Earth, then such a disarrangement of the solar rays would not exist; instead, there would be darkness. However, since the dense mass would present resistance to the solar radiations, such resistance would be enough to produce heat, and such a dense mass - when opposing the solar radiation - could become resplendent by the transformation of the solar radiation, and

could produce not only heat but also light; therefore, in any case there would be light, yet with unbearably high temperatures.

Chapter 4
The Inhabitants of the Sun Sirius

We understand that Sirius is the capital of this entire galaxy in which we live. This galaxy, the Milky Way, the Macrocosmos, has many millions of solar systems and all of those suns and planets rotate around the central sun Sirius, which is a sun millions of times bigger than the sun that shines upon us. Sirius has its twin brother, which is a moon 5,000 times more dense than lead. Such a moon rotates around Sirius incessantly; Sirius is therefore a double star.

It is very intriguing to know that the nucleus of this great galaxy is properly polarized. Thus, from Sirius come irradiations that govern the superior dimensional heavens of the different worlds that form this galaxy; and from its twin brother, which is that very heavy moon 5,000 times more dense than lead, come all of those negative, tenebrous influences that characterize each one of the moon-satellites that rotate around their respective worlds; these are fatal, sinister radiations that govern the infra-hells. There is a third force that we would call neutral, which allows a certain balance between these positive and negative powers. Observe how this galaxy is properly equilibrated between light and darkness, between positive and negative.

Sirius in itself is a gigantic world with rich mineral, plant, animal, and human life. Its inhabitants are very small in stature: they do not even reach one meter in height. I understand that they average a half a meter in height, are thin in their bodies' composition, and have a beautiful presence, since they are true Adepts of the White Brotherhood.

One cannot reincarnate on the sun Sirius if they have not have reached the Kumara stage, since those human beings are true Gods. They live humbly in the woodlands; none of them have the detrimental idea of building cities, since the habit of building cities belongs to unintelligent people; therefore the inhabitants of Sirius would never fall into such a mistaken inclination.

So, they have humble houses. They use tunics that are woven simply. Each house has its own orchard where the Siriuseans harvests their goods, and gardens where they cultivate their flowers. They live in peace and harmony with each other.

None of them would have the unwise idea of making wars or something of the sort, since all of that is barbarism and savagery. Siriuseans are a very cultural people, true enlightened humans in the most transcendental sense of the word.

The Transcended Church is there. One is astounded when entering into that temple of marvels. The great initiates of this galaxy officiate there; I have attended its ceremonies many times.

The Cosmic Drama, which is the life, passion, and death of Christ, is constantly celebrated or lived in this temple. We find the God Sirius and all of his initiates, his disciples, within the heart-temple of that gigantic world, of that extraordinary sun. Indeed, Sirius is the capital of this great galaxy within which we live.

Chapter 5
Useless Dreams

Let us now talk about something very important: I want
to emphatically address the subject-matter related with dreams.
The hour in which we must delve deeply within this topic has
arrived.

I acknowledge that the most important thing is to stop
dreaming, since indeed, dreams are nothing other than mere
projections of the mind and are, therefore, illusions; they are
worthless.

It is precisely the ego who projects dreams, and obviously
those dreams are useless.

We need to transform the subconsciousness into con-
sciousness. We need to radically eliminate not only dreams,
but moreover, we must also eliminate the very possibility of
dreaming, and this is difficult, since it is unquestionable that
such a possibility will always exist so long as subjective elements
continue to exist within our psyche.

We need a mind that does not project; we need to exhaust
the process of thinking. The projector-mind projects dreams,
and these are vain and illusory. When I talk about the mind as
being a projector, I am not referring merely to "projects," such
as the ones made by an engineer who sketches or designs the
blueprints for a building, a bridge, or a road, no; when I am tak-
ing about the mind as a projector, I am addressing the mind of
every intellectual animal. It is clear that the subconsciousness
always projects not only houses, buildings, or things of the sort;
to be clear, it also projects its own memories, its own desires,
its own emotions, passions, ideas, experiences, etc. Again, the
projector-mind projects dreams, and it is clear that projections
will exist as long as the subconsciousness continues to exist.
When the subconsciousness ceases to exist, when it has been
transformed into consciousness, then projections cease, they
can no longer exist, they disappear.

If we want to attain authentic illumination, then it is necessary and urgent to transform the subconsciousness into consciousness. Indubitably, such a transformation is only possible by annihilating the subconsciousness. Yet, the subconsciousness is the ego; so then, we must annihilate the ego, the "I", the myself, the self-willed. Yes, this is how the subconsciousness is transformed into consciousness. Consequently, it is necessary for the subconsciousness to cease to exist, so that the objective, real, and true consciousness can appear and occupy its place.

In other words, as long as any subjective element - as insignificant as it might be - continues to exist within each one of us, here and now, the possibility of dreaming will persist; however, when the subjective elements are terminated, when not a single subjective element lingers within our psyche, then the outcome is objective consciousness, authentic and true illumination.

Thus, an individual who possesses objective consciousness, who has eliminated the subconsciousness, lives completely awakened within the supersensible worlds, and while his physical body sleeps in the bed, he will move in those worlds willingly: seeing, hearing, and perceiving the great realities of the superior worlds.

Therefore, it is one thing to go about within the hypersensible worlds with objective consciousness, in other words, with awakened consciousness, and it is another to do so in a subjective or subconscious state, in other words, by going around projecting dreams.

Lo and behold the great difference between the one who goes around projecting dreams within those hypersensible regions, and the one who lives there without making any projections, who has his consciousness completely awakened, illuminated, in a state of a super-exalted vigilance. Obviously, the latter is truly an enlightened one, and can (if he wishes) investigate the mysteries of life and death and know all of the enigmas of the universe.

A certain author states somewhere that dreams are nothing other than disguised ideas, and if this statement is factual, we then can clarify this matter a little more by stating that "dreams

are projections of the mind" and therefore, are false and vain; thus, whosoever lives awakened no longer dreams.

Without having died within themselves, without having annihilated the ego, the "I", the myself, no one can live awakened; this is why I want all of you brothers and sisters to occupy yourselves with the disintegration of your egos, because only thus, by disintegrating your terrible legion, can you be radically awakened.

Indubitably, to eliminate our subjective elements is not easy, since they are many and widely varied. This elimination is processed in a didactical way, little by little. Therefore, accordingly, as one is eliminating such elements, one is objectifying one's consciousness. Thus, when elimination has become absolute, then the consciousness has become totally objectified, awakened; then the possibility of dreaming has been terminated, concluded.

The great adepts of the Universal White Fraternity do not dream, since they possess objective consciousness; for them, the possibility of dreaming has disappeared. Thus, one finds them within the superior worlds in a state of intensified vigilance, totally illuminated, and directing the current of the innumerable centuries, governing the laws of nature, converted into Gods who are beyond good and evil.

It is therefore indispensable to comprehend this matter in depth. Thus, in order for all of you to have an exact summary of this, I want to tell you the following:

1. The subconsciousness is the ego; thus, annihilate the ego and the consciousness will awaken.

2. The subconscious elements are infrahuman elements that every one of us carries within, therefore destroy them and the possibility of dreaming will cease.

3. Dreams are projections of the ego and therefore they are worthless.

4. The ego is mind.

5. Dreams are projections of the mind.

6. You must mark down the following with much attention: It is indispensable to stop projecting.

7. We must not only stop projecting things of the future, but of the past, since we live constantly projecting things from yesterday.

8. We must also stop projecting every type of present emotions, morbidities, passions, etc.

The projections of the mind are therefore infinite; as a consequence, the possibilities of dreaming are infinite. Therefore, how can a dreamer be considered an illuminated one? Obviously, the dreamer is nothing other than a dreamer who does not know anything about the reality of things, about that which is beyond the world of dreams.

It is indispensable that our brothers and sisters of the Gnostic Movement concern themselves with their awakening, thus, for this, it is required that they truly dedicate themselves to the dissolution of their "I," their ego, their myself, their self-willed; may that be their main preoccupation. Accordingly, as they are dying within themselves, their consciousness will become each time more and more objective; thus, the possibilities of dreaming will diminish in a progressive way.

It is indispensable to meditate in order to comprehend our psychological errors. When one comprehends that one has this or that defect or error, one can give to oneself the luxury of eliminating it, as I taught in my book entitled *The Mystery of the Golden Blossom*.

To eliminate this or that error, this or that psychological defect, is equivalent to eliminating this or that psychological aggregate, this or that subjective element, within which subsists the possibilities of dreaming or projecting dreams.

When we want to eliminate a defect, an error or a psychic aggregate, we must first of all comprehend it; nonetheless, brothers and sisters, it is not enough to only comprehend, it is necessary to delve even deeper, to be more profound: it is necessary to "capture" the deep significance of that which one has comprehended, and one can only achieve such a "capture" by means of a very internal, in-depth, profound meditation...

The one who has captured the deep significance of that which has been comprehended has the possibility of eliminating it. To eliminate psychic aggregates is urgent. Psychic aggregates and psychological defects are basically the same, thus any psychic aggregate is nothing else than the expression of a type of psychological defect...

That there is the need to eliminate them, this is clear, however, we must first of all comprehend them and also to have captured their deep significance. Thus, this is how we die from moment to moment; the new comes to us only with death.

Many want to be awakened in the astral, mental, etc., planes, yet they do not preoccupy themselves with psychological death, and what is worse is that they confuse their dreams with true mystical experiences. Dreams, which are nothing other that simple projections of the subconsciousness, are one thing, yet real mystical experiences are another thing. Any authentic mystical experience demands the state of alertness and awakened consciousness. I cannot conceive of mystical experiences with sleeping consciousness. Therefore, the mystical, real and authentic experience only arrives when the objectiveness of the consciousness has been achieved, when we are awakened.

May all our brothers and sisters profoundly reflect upon all of this. Study our book *The Mystery of the Golden Blossom*. May everyone preoccupy themselves with dying from moment to moment. Only in this way can they achieve the total objectiveness of their consciousness.

QUESTION: Master, are all of those crowds who go everywhere running like mad people asleep? Are they going around projecting? Are they dreaming? Are they alienated to themselves?

ANSWER: Indeed, those people who go everywhere in a mad rush, running, they are dreaming. It is not necessary for their physical bodies to be resting, snoring in their beds at midnight, in order for them to be dreaming. People dream right here in flesh and bone, just as you see them, running as mad people in the street, as they go around in this constant coming and going, like machines without rhyme or reason, nor any orientation. Thus, in

the same way they go around within the internal worlds when their physical body sleeps in their bed.

Regrettably, what happens is that people who are daydreaming in their life, that go around dreaming in their wrongly called "state of vigil" (since, in that state, one always see them sleeping, dreaming), when the hour in which their physical bodies must rest in their bed arrives, they abandon their physical vehicle and penetrate within the supersensible worlds; however, they carry their dreams to such regions. In other words, each one carries their dreams to the internal worlds, as much as during the hours in which the physical body is sleeping, as well as after their physical death.

Indeed, people die without knowing how, and, dreaming, they enter into the internal worlds and there they live, dreaming; thereafter, they are born without knowing at what time or how, and continue going around dreaming in their practical life constantly.

Therefore, it is not strange that people accidentally die under the wheels of cars, that they commit so much madness, since this happens because they have their consciousness asleep, since they are dreaming...

It is indispensable to cease dreaming. The one who ceases dreaming here and now also ceases dreaming in any corner of the universe and can then go everywhere awakened. The one who awakens here and now awakens in the infinite, in the superior worlds, in any place of the cosmos.

What is important is to awaken here and now, in this very moment in which we are talking, to awaken from instant to instant, from moment to moment.

Chapter 6
Key of SOL

Unquestionably, the most important thing in life is the realization of the inner Being. Once, I interrogated my Divine Mother Kundalini, as follows:

"How is it that the path that leads to the resurrection is extremely long?"

She answered me, "It is not that the path is too long; rather, the work with the philosophical stone is very hard: it must be worked, chiseled. It is necessary to give the brute stone a perfectly cubic shape."

Our motto is Thelema, meaning "willpower."

We must begin by awakening the consciousness. Obviously, all human beings are asleep, and in order to see the path it is necessary to be awakened; thus, what is essential is to awaken here and now. Unfortunately, people sleep; it seems incredible, but this is how it is.

We wander in the streets with the consciousness asleep; we are in our house, in our job, in the body shop, in the office, etc., with the consciousness profoundly asleep. We drive our car and we go to the factory with the consciousness tremendously asleep.

People are born, they grow, they breed, they get old and die with the consciousness asleep; thus, they never know where they come from nor the objective of their own existence. What is most grave in this matter is that all of them believe that they are awake.

For instance, many people are preoccupied in knowing many esoteric things, yet they never occupy themselves with the awakening of their consciousness. If people had the purpose of awakening here and now, then immediately they could know all of that which for them are enigmas; this is why skepticism exists, because the skeptical is ignorant, and ignorance is the outcome of a sleeping consciousness.

Indeed, I want to tell you in the name of the truth that skepticism exists because of ignorance. Therefore, the day when the people awaken their consciousness they will stop being ignorant, and, as a fact, skepticism will disappear, because ignorance is equal to skepticism and vice versa.

Indeed, Gnosis is not a doctrine that seeks to convince skeptical people, because if today we convince 100 skeptical individuals, tomorrow we have to convince 10,000, and if we convince the 10,000, then 100,000 will appear who want to be convinced, and so on and so forth, thus, we will never be done.

The system to attain the inner realization of the Being is a matter of "cognizant works" and "voluntary sufferings," yet, the continuity of purpose in the three factors of the revolution of the consciousness is necessary. Logically, in order to achieve the awakening of the consciousness, it is necessary to die from instant to instant, from moment to moment.

The sleeping person ends up intoxicated when in the presence of a cup of liquor. The sleeping person ends up fornicating when in the presence of the opposite sex. Thus, the sleepy ones becomes identified with everything that surrounds them, and forget about their selves.

From my memory—at this very moment—I recall the unusual case of Piotr Demianovich Ouspensky, who when walking on the streets of Saint Petersburg, had the resolve to remember his self, and to not forget about himself, not even for an instant. Thus, he said that as he remembered himself from moment to moment, he even perceived a spiritual aspect within all things, and while this type of spiritual lucidity was increasing he felt his psyche gradually transformed, etc. Nevertheless, something very discouraging happened to him: all of a sudden he felt the necessity to enter a smoke shop in order to select some tobacco. Certainly, after being attended and provided with his order of cigars, he left the smoke shop very quietly while smoking along an avenue. Thereafter, remembering different things and occupied in diverse intellectual matters, etc., he walked through different places of Saint Petersburg; in other words, he became absorbed within his own thoughts.

An hour and a half later—already at his home—he observed very well his room, his bedroom, his living room, his desk, etc., and suddenly, he remembered that he had first wandered through many places with his consciousness awake, but after having entered into the cigarette shop his psyche had fallen asleep again, and thus, his good intentions of remaining awake from moment to moment were reduced to cosmic dust; thus, he regretted the incident. He took an hour and a half to reach his home, and during that entire time, he regrettably treaded the streets of the city with his consciousness completely asleep.

Behold how difficult it is to remain with the consciousness awake from instant to instant, from moment to moment, from second after second. However, if one has true longings for becoming fully awakened—this is the beginning—one must not forget oneself, not even for a moment.

Yes, one must keep remembering oneself wherever one walks—in any living room, or on whichever street one goes by walking, jogging, or riding a car, whether it be night or day—wherever one might be, at work or in the shop, anywhere: one must remember oneself while at the presence of any beautiful object, or while before any window-shop where very beautiful things are being shown, etc.—in other words, one must not become identified with anything that one likes or is captivated by.

Subject

The person needs to always keep remembering himself: not only his physicality, but also one needs to watch one's own thoughts, feeling, emotions, deductions, appetencies, fears, longings, etc.

Object

Beloved brothers and sisters, it seems to me that this second aspect (object) is abundantly intriguing, because it is related with becoming inquisitive about objects, that is, with "not becoming identified with things" as we already stated; thus, if you see a beautiful object—i.e. a suit within a window-store, or an

exposition of something, or an exhibition of anything: a very beautiful car, a pair of wonderful shoes, anything—what is important is to not become identified with the thing, and to know how to distinguish between common things and uncommon things, like a strange animal, an elephant that flies, or a camel that appears in the middle of the living-room, etc.; thus, the first thing that one needs to do is to reflect.

One needs to not become identified with the object or creature that one sees, because if one becomes identified with what one sees, that is, if one is absorbed by the representation before one's eyes, then one remains fascinated; in other words, one passes from identification to fascination, and this is how one remains enchanted, marveled, identified. If one forgets oneself, then thereafter one's own consciousness falls asleep, it will snooze profoundly.

Thus, my dear brothers and sisters, the only thing that one achieves with this mistaken behavior—that is, by allowing oneself to become foolishly fascinated with objects—is to deactivate the consciousness, to put it to sleep, and this is critical, very critical, very critical... very critical...

Location

From my memory—at his very moment—I recall another unusual case: many years ago when I was traveling through the countries of South America—since as a traveler I always walked from one country to another around the world—on a given night it so happened that I saw myself waking through a garden, then into a living room and through it, and finally I arrived at a lawyer's office, where I saw seated at a desk a lady of a certain age, with grey hair, who very amiably attended me; she stood up and greeted me.

Suddenly, I observed that two butterflies made of crystal were on the desk—well, there is nothing odd about seeing two butterflies on a desk, right? Yet, the intriguing aspect of this matter is that the two butterflies were alive: they were moving their wings, their little heads, their little legs, and that is very odd, right? So, this was very unusual and intriguing: two but-

terflies made of crystal, and alive! These butterflies were not normal; it is clear that they were not natural, my beloved brothers and sisters, this was something odd; it was a case where one has to become very inquisitive.

Well then, do you want to know what I did? I did not become identified with the pair of butterflies, I only pondered the following question within myself: "How is it possible that there exist in the world butterflies whose bodies are made of crystal, whose head, legs, and wings are made of crystal, and that breathe and have life like the natural ones?" Thus, this is how I reflected, my beloved brothers and sisters.

What if I had become identified with the butterflies and not pondered an analytical question, without reflecting on those butterflies made of crystal? What if I had become fascinated, or enchanted, and had fallen into unconsciousness? Well, that would have been foolish, right?

However, I reflected, by pondering the following statements to myself: "No! It is impossible for these type of creatures to exist in the physical world. No, no, no, this is very strange, this is very odd, this is not normal. Here, I smell something fishy, there is something rare. This type of phenomenon, as I know, does not exist in the tridimensional world; since this is only possible in the astral world, it seems that I am in the astral dimension; could it be that I am in the astral world?"

Then, I question myself: "It seems that I am dreaming, it seems that I left my physical body sleeping somewhere, because indeed this is very odd. So, in order to be sure, I am going to perform a small jump with the intension of floating in the environment, thus, this is how I will verify if I am in my astral body, so let us see what happens." So, this is what I said to myself, yes brothers and sisters, with complete confidence I tell you that this is how I proceeded. It is obvious that I had to proceed in that manner and not in another manner, right? However, I was concerned about jumping in front of that lady; thus, I said to myself, "This lady might think that I am a nut case if I start jumping here in her office."

Apparently, everything was very normal: a desk like any desk, the chair where the lady was seated was one of those that rotate from one side to the other, there were two candelabra in that office, I remember that one was at the right and the other at the left, they seem made of massive gold. So, I remember this with entire exactitude, my dear brothers and sisters, even though it happened a long time ago, many years, since I was very young in that epoch, thus, I remember that the candelabra were of seven branches. Well, talking here with complete confidence, I did not find anything odd in that room, everything was normal in that office, however, when I focused my sight in those butterflies they became the only truly questionable oddity there. As for the rest, I said: "There is nothing odd about this lady, she as normal as other ladies in the world; however, these butterflies make me intrigued." The fact that they were alive on their own accord was very rare. Anyhow, be it as it is, I resolved to leave the room with the intention of performing a little jump, do you understand? Of course, I had to give an excuse to the lady, thus, I asked her consent to leave the office; I told her that I needed to leave the room just for a moment, and that I did.

Thus, when outside in the corridor and being sure that no one was looking at me, I performed a long jump with the intension of floating in the environment... and behold, let me tell you what happened, sincerely I tell you that I immediately remained floating in the surrounding atmosphere. Of course, I felt a delectable sensation, my dear brothers and sisters, a delectable sensation; then I said to myself: "I am in my astral body; here I do not have even the slightest doubt about it." I remembered that a few hours before I had left my physical body sleeping in my bed and by displacing myself there in the astral world I had arrived to that place, to that office.

Then, I went back into that office, I sat again before the lady and spoke to her with much respect, I told her: "Be aware, ma'am, that we both are in the astral body." Wondering, with sleepy eyes like a somnambulist, that lady scarcely looked at me; she did not understand, she did not comprehend, nevertheless, I wanted to clarify the situation for her and I told her: "Ma'am, remember that a few hours ago you went to bed, to lay down in

order to sleep, therefore, do not wonder why am I telling you this; listen: your physical body is sleeping in your bed and you are here talking with me in the astral world..."

Yet, definitively, that lady did not understand; she was profoundly asleep, she had her consciousness asleep. Thus, upon seeing that everything was useless, comprehending that she would not awaken—not even with cannon shots, since that wretched lady had never dedicated herself to the labor of the awakening of her consciousness—frankly, my dear brothers and sisters, I resolved to apologize, and left.

Well, as a curious thing, I want to narrate for you that many years after, maybe 30 years or more, I had to travel to Taxco, Guerrero, Mexico. Taxco is a very beautiful town, situated over a hill and built in the colonial style; its streets are stone-paved as in the epoch of the colonization, and it is very rich indeed; it has many silver mines, and many beautiful objects and jewelry made of silver are sold there.

I had to travel to that town because someone I was making some remedies for someone who lived there; he wanted to be healed and wanted me to help him in his healing process; he was a wretched patient, very sick...

Well, I arrived at a house, I crossed a garden, and arrived at the living room, which I recognized immediately. There was there a lady; I looked at her and recognized her: she was the same lady that I had seen behind the desk many years ago in the astral world; however, this time she was in the living room.

She invited me to pass into another room, where I found the already mentioned lawyer's office, where I, so many years ago, had arrived in my astral body. Yet now, instead of the lady behind the desk, it was her husband, a very well educated man who without a title was dedicated to the law (in some places these people are call interns); well, call them as you please. The fact was that he was seated there, in said office. He stood in order to welcome me and thereafter he invited me to sit down in front of his desk. So, I had immediately recognized the office and the lady.

Then, it so happened that because that man had some liking for these sort of spiritual studies, we talked and conversed for a while on these matters; he liked everything related with esoteric studies. Thus, I surprised him a little when I told him:

"Sir, I was here already some time ago. I was out of my physical body, in my astral body, and you know it moves, walks, and goes from one place to another." This gentleman already knew a little about these things, so my statement was not unusual to him.

Then I told him: "See, on this desk there were two butterflies made of crystal. What happened, where are those butterflies?"

He quickly answered me: "Here are the butterflies, right here, look at them." He then raised some newspapers that were upon the desk and certainly, they were there, the two very beautiful butterflies made of crystal... Of course, he was very astounded that I knew about those butterflies.

Then I told him, "But something else is missing. I see one candelabra of seven arms, yet I saw two. Where is the other, what happened to it?"

"Here is the other one, look at it," the gentleman in his office answered me. He then removed some papers and newspapers that he had there and indeed he showed me the other candelabra, yes, it appeared in order to confirm my assertions even more. Of course, the man was amazed.

Then I told him: "I want you to know that I know your wife, because when I came here your wife was at the desk." Well, the gentleman was amazed.

Thus, at dinner time we were seated at a round table and something truly unexpected happened: in the presence of her husband, the lady told me, "I met you a long time ago. I do not know exactly where, but I have seen you... Yes, I have seen you before in some place. Anyhow, you are not an unknown person to me."

Then, I immediately elbowed the gentleman and told him: "Do you realize it? Are you convinced of my words?"

Well, the amazement of that man reached its maximum. Unfortunately—and this indeed is what is very critical, my beloved brothers and sisters—that man was so attached to his sect, which we might call a type of Romanist sect, that frankly speaking, he did not enter into the path due to sectarian matters. Otherwise, he would have come to the path, because I gave him extraordinary evidence that for him were factual and definite; at least, he became forever amazed, did he not? Regrettably, his beliefs did not allow him, they confused him, he became entangled in all those religious dogmas, etc. Well, many years have already passed, nevertheless I still have been able to narrate this event for you.

Thus, this is why I recommend to you the division of attention into three parts:

1. SUBJECT: that is to say, oneself. One must not forget oneself, not even for an instant.

2. OBJECT: to observe all things, as in the case of the butterflies that I have narrated to you. What if in this very moment in which you are reading this book, a person that died many years ago arrived to your home and spoke to you. Would you be so naive, would you be so absent minded, as to not ask yourself: "What is this? Could it be that I am in my astral body?" Would you be as reckless as to not do the experiment and to give a little jump?

Well then, do not forget that any detail, as insignificant as it may appear, must be enough in order to perform this type of inquisition. Thus, every object must be studied in detail, and thereafter one must ask oneself: "Why am I here?"

3. PLACE: one must not live unconsciously. When we arrive at any place, we must observe it in detail, very minutely, and thereafter ask ourselves: "Why am I here, in this place?" And by the way, you that are reading this book, tell me: did you already ask yourself why are you there in that place where you are reading? Did you already inconvenience yourself to observe that place, the ceiling or the walls, or the space that surrounds you? Are you already observing the floor or the place, up and down, to the sides, behind you, and in front of you? Did you already

look at the walls and your surroundings in order to ask the question, "Where am I?" And if you did not do it, why do not you try? Or, perhaps you are reading this book unconsciously?

It is clear that you must never live unconsciously, no matter where you are: in a house, on the street, in a temple, or in a taxi, on the sea or in an airplane, etc. So, wherever you may be, wherever you are to be found, the first thing that you must ask to yourself is, "Why am here I in this place?"

Look minutely at everything that surrounds you: the ceiling, the walls, the floor; that observation is not only for the park, the house, or an unknown place, but one must do it daily, all the time. Look at your house as if it was something new or unknown; do so every time and every moment that you enter into it. You must also ask yourself, "Why am I in this house? What a strange house.." Then look at the ceiling, the walls, and the ground, at the patio, etc.—everything in detail—then ask yourself the question: "Why am I in this place? Could it be that I am in my astral body?" Thereafter, perform a little extended jump with the intention of floating in the environment.

If you do not float, but still feels that you are in your astral body, then go stand on top of a chair or on top of a low table, an ottoman, a strong box or something of the sort, and jump in the air with the intention of floating. Sometimes one performs the extended jump and nevertheless one does not float, thus the best solution is to go and stand on something that allows us to jump in the air in order to hover in the environment when one jumps with the intention of flying. Thus, it is clear that if one is in the astral world, one remains floating in the environment and if not, then one returns to the ground.

So, do not forget the division of attention into three parts: SUBJECT - OBJECT - LOCATION.

If one becomes accustomed to live with the attention divided into these three parts—subject, object, and location—if one is habituated to do it daily, at every moment, from instant to instant, from second to second, then this habit becomes recorded deeply in the consciousness; thus, at night, when our physically body sleeps, one performs the exercise in the astral

world, one does the same thing that one does in the physical body: the outcome is the awakening of the consciousness.

You know that often at night you repeat in dreams the same things that you usually do during the day. For example, during the day many work in a factory, or as traveling salesmen, or in an office, then at night during their dreams they see themselves working, doing exactly the same things that they do during the day: they dream that they are in the factory, or selling, or in the office, etc. It is clear that everything that you do during the day you repeat during the night, that is to say, you dreams the same thing at night.

So, it is a matter of performing this practice during the day, at every hour, at every moment or second, in order to achieve it during the night, and thus awaken our consciousness.

It is clear that when any person is physically sleeping, the Essence, the consciousness is far from the physical body; then it so happens that when the Essence is outside of the physical body, it acts within the astral body, and repeats the same things that it does during the day. This is how you can awaken automatically, because the practice of this exercise gives a spark or shock to your consciousness, which then remains awake.

Thus, my dear brothers and sisters, when one is already awake in the astral world, one can invoke the Masters, for example, one can call the Angel Anael or the Angel Adonai - the child of light and happiness - or the Master Khut Humi, so that they can come to instruct us, to teach us, etc. Likewise, you can call any other Master, namely Morya, the Count Saint Germain, etc. and those who invoke me they can be sure that I will concur to their call; they should be sure.

Therefore, I give you the system in order to receive the teachings directly, and if you want to remember your past lives, then invoke the Masters of the White Lodge, Khut Humi, Hilarion, Morya, etc., and ask them to have the amiability, the kindness, to help you to remember your former existences, to help you to recall your past lives. You can be sure that the Masters will grant you such a petition.

This system that I am giving to you all is in order for you to receive the direct knowledge. You can also travel to Eastern Tibet, you can also go to the depth of the oceans, including to other planets if you want...

Thus, this it is the way to receive direct knowledge. This is why I tell you:

Awaken, my dear brothers and sisters, awaken, awaken; do not continue living your life as unconscious or asleep individuals, as this is very sad, my dear brethren. Behold the sleepy souls, how they walk unconsciously in the astral world, and after the death they continue asleep, unconscious, and dreaming foolishness. They are born without knowing at what time, they die without knowing at what time. I do not want that you continue like this, within that terrible unconsciousness. I want you to awaken.

Chapter 7

The Common-Cosmic
Trogoautoegocrat Law

In name of the truth I must state that a great law exists, which can be addressed as: The Common-Cosmic Trogoautoegocrat Law. This law has two fundamental, basic factors: to swallow and to be swallowed—or, the reciprocal nourishment of all organisms. Unquestionably, the bigger fish will always swallow the smaller fish, and in the depths of the jungle the weaker will succumb before the stronger; thus, this is the law of life.

It does not matter how vegetarian we may be, the truth is that in the black sepulcher our body will be devoured by maggots, since the Common-Cosmic Trogoautoegocrat Law must be fulfilled.

Unquestionably, all organisms live on other organisms; i.e., if we descend into the interior of the Earth, we will discover a metal that serves as a gravitational mediator for the evolving and devolving forces of nature; I am emphatically referring to copper (Cu). For example, if we apply the positive factor of the electricity to this metal, we can then evidence—with the sixth sense—wonderful evolving processes in molecules and atoms. If we apply the negative force, we then see the inverse process, that is, we see very similar devolving processes to those of this declining humanity of our times. Naturally, the neutral force would then maintain such a metal in a static or neutral state.

Obviously, the radiation of copper is also transmitted to other metals that are found inside the Earth and vice versa; the emanations of those metals are received by the copper, thus this is how the metals, inside the Earth, are reciprocally nourished; behold here the law of the Eternal Common-Cosmic Trogoautoegocrat.

It is astonishing to know that the radiation of all the metals within the entrails of the Earth—where they develop—is transmitted to other planets of the infinite space. Yes, the emanations of the Earth arrive to their interior; that is to say, Earth's

vibrations arrive at the living entrails of neighboring planets of our solar system. Earth's radiations are captured by the metals located in their interior, and likewise the planets also radiate, so their irradiations are energetic undulations that arrive at the interior of our world, in order to nourish the metals of our planet on which we live, move, and have our Being.

All the worlds are sustained by all the other worlds; this is obvious, unquestionable, evident, and manifest. Thus, the cosmic balance is based upon this law of reciprocal planetary nourishment. This is fascinating, right? Yes, it is fascinating to know that by this reciprocal nourishment amongst the worlds, by one sustaining the others, a wonderful and perfect planetary balance is adjusted.

The water on all the worlds is, indeed, the basic nourishment for the crystallization of this great law of the Eternal Common-Cosmic Trogoautoegocrat. Let us think for a moment: what would become of our planet Earth, what would become of all the plants and animals, all the creatures, if the water were to evaporate, disappear, vanish, finish? Obviously, our world would become a great moon, a cosmic corpse, and the great law of the Eternal Common-Cosmic Trogoautoegocrat could not crystallize, since all the creatures would perish by starvation.

Indeed, this great law is processed in accordance with the laws of the Holy Triamazikamno, or Triamenzano (Holy Three) and of the Sacred Heptaparaparshinokh (the Law of Seven). Let us observe well the process of the law of the Holy Triamazikamno: for example, an active principle approaches a passive principle, or to be more precise, the victim (passive principle) is swallowed by the active principle; this is how this law is, right? The active principle is the positive pole, the passive principle is the negative pole, and the principle that conciliates both is the third force, the neutral force. The Law of Three is formed then by the three principles: Holy Affirmation, Holy Negation, and Holy Conciliation. The latter is of course the force that conciliates the affirming force with the negating force, thus, this is how the victim is devoured by the predator, that is, the victim is devoured by the predator to which it corresponds, in accordance with the law, understood?

Another example: the tiger swallows the humble rabbit; here the tiger would be the Holy Affirmation, the rabbit the Holy Negation, and the force that conciliates both of them is the Holy Conciliation; thus, this is how the law of the Eternal Common-Cosmic Trogoautoegocrat is processed.

Again: the eagle is the Holy Affirmation, the wretched chick is the Holy Negation, and when the eagle swallows the chick, the third force, the Holy Conciliation, conciliates them and make them a unique whole. Is this law cruel? Yes, so it appears. What can we do: this is how the law of the worlds is; this law has always existed, it exists, and will always exist. Law is law, and this law is fulfilled in spite of opinions, concepts, customs, etc...

Nevertheless, let us continue, because it is necessary to delve a little more, to penetrate to the bottom of this subject. From where in fact comes this law of the Eternal Common-Cosmic Trogoautoegocrat? I say that this law comes from the omni-penetrating, omniscient, omni-merciful, active Okidanokh.

Likewise, from where does this active Okidanokh emanate? What is its causa causarum? Unquestionably, its origin or cause is none other than the Sacred Solar Absolute. Therefore, the Holy Okidanokh emanates from the Sacred Absolute Sun; yet, notwithstanding that this active Okidanokh is, we might say, within the worlds, it does not remain completely involved within them, since it cannot be imprisoned, even though for its creative manifestation it needs to divide itself asunder into the three forces known as positive, negative, and neutral.

During the cosmic manifestation, each one of the three forces works independently, but always united to its origin that is the Holy Okidanokh. After any manifestation, these three factors or ingredients—positive, negative, and neutral—become fused again, are united again with the Holy Okidanokh; thus, at the end of the Mahamanvantara, the complete, total, and in-tegrated Holy Okidanokh is reabsorbed within the Sacred Solar Absolute.

See then, by yourselves, dear brethren, the origin of the Eternal Common-Cosmic Trogoautoegocrat. Thus, when we start from this principle, vegetarianism remains without

a foundation. Obviously, the fanatics of vegetarianism have made a kitchen-religion out of vegetarianism, and this is indeed lamentable.

The great Tibetan Masters are not vegetarian. Those who doubt my words can read the book entitled *Beasts, Men, and Gods,* written by a great Polish explorer who was in Tibet and who was welcomed by the Masters. The intriguing aspect of his case is that he wrote that beef appeared as a basic food in all the banquets and festivities that he attended. My words might seem absurd unto the fanatics of vegetarianism, nevertheless, Ferdinand Ossendowski, the author of the mentioned book, will be glad because he will see that I have comprehended this important aspect.

It is therefore absurd to affirm that the great Masters of Tibet are vegetarian. When the great initiate Saint Germain, Prince Rakoczy—a great Master of the White Lodge who directs the ray of world-wide politics—to be more precise, Saint Germain, the one who worked during the time of Louis XV—never manifested himself as vegetarian; people saw him eating everything at festivities; for example, some even commented how he savored chicken meat.

From where, therefore, come these matters about vegetarianism, since, unquestionably, the vegetarian school is against the Eternal Common-Cosmic Trogoautoegocrat; this is obvious. On the other hand, animal proteins must not be despised in any way, for these are indispensable for our nourishment.

I was a vegetarian fanatic and in the name of the truth I tell you that I became disappointed with that system. Still I remember that time in La Sierra Nevada when I wanted to make a wretched dog become one hundred percent vegetarian. That animal learned; it became accustomed to the vegetarian system, but it died immediately after learning it. Nevertheless, I observed the symptoms of that creature, the weakness that it demonstrated before dying. So, later in time, in the neighboring Republic of El Salvador, one given day when I was returning to my home, the same symptoms appeared in me when I was walking up a long street that tended to be more vertical than horizontal, since it was very steep. I was sweating frightfully and as

my weakness increased horribly with each step, I thought that I was going to die. I did not have any alternative than to call my spouse, the Master Litelantes, and to ask her to cook beef for me; she did so, and I ate it. Then the energies returned into my body, and I felt that I returned to life... Since then, I have been disillusioned with the vegetarian system.

Here in Mexico I knew precisely the director of a vegetarian school; I knew him in a vegetarian restaurant. He was a German; his body became terribly, frightfully weak, until it displayed the same symptoms of that dog of my experiment. The unfortunate gentleman, terribly weak, finally died.

I also knew Lavahniny, a Yogi, gastrologer, and who knows what other things—an unbearable vegetarian fanatic—he represented the Round Table University here in Mexico. His organism became terribly weak with vegetarianism; it displayed the same symptoms of that wretched dog of my experiment, and died.

Therefore, dear friends and brethren that read this book, you must know that the great law of the Eternal Common-Cosmic Trogoautoegocrat exists and that it is useless for us to try to evade such a holy law, which emanates, as I already stated, from the active Okidanokh, and it is not possible to alter it.

I do not mean with this that we must become carnivorous in an exaggerated manner, no: it is better that we become equilibrated. Dr. Arnold Krumm-Heller stated that we need to eat about 25% meat in our foods, and in this I agree with the Master Huiracocha.

I repeat: it does not matter how vegetarian we become, the law will be fulfilled; thus, when we go into the burial grave the maggots will swallow our body, whether we like it or not, because the law is the law; this is obvious, right?

The cows are vegetarian one hundred percent, and nevertheless, as a great initiate stated, we have never seen an initiated cow.

If by avoiding the eating of meat we could become thoroughly Self-realized, I can assure you that even if I died because of it, I would stop eating meat and would advise others to stop

eating meat. But nobody will become more perfect because he does not eat meat.

Some even state that how are they going to put animal elements within their organism if they are already on the path of perfection, etc.? Those who state such things ignore their own internal constitution; indeed, it is better for them to eat a piece of meat than to continue with those bestial aggregates that they carry within their psyche.

The human body has as its foundation a vital body, the linga-sarira of which the theosophists speak; beyond this vital depth, what exists within the organisms of these living and intellectual humanoids? The animalish aggregates, those psychic aggregates that personify our errors, those beastly monsters of our passions are what exist.

Well then, it is better to eliminate those beastly monsters than to worry about that small piece of meat served at the table at the time of our meals. When we eat beef or chicken, we do not harm ourselves whatsoever, nevertheless, we harm ourselves with all those beastly aggregates that we carry within—moreover, we also harm our fellowmen with them, and this is worse.

Is not anger a beastly monster? What about greed, lust, envy, pride, laziness, and gluttony? And what can we say about all of those beasts that we carry inside that represent defamation, slander, and gossip, etc?

It is better for us to not wash our hands like hypocrites and to not boast of being saints; the hour has arrived in which we must become more comprehensive. What is important is to die within ourselves, here and now. Nevertheless, with these statements I do not want to deny the selection of our food. In no way would I advise, for instance, pork; it is already known that pigs are leprous and that they have a very brutal psyche that harms our organism.

Healthy food is convenient—cattle meat, chicken—but without reaching excesses, because excesses are harmful and damaging.

Well, my dear brothers and sisters, I believe that with what I have said about vegetarianism you have enough guidance in

order to know how to nourish your body without deficiency or excess, within a perfect equilibrium; that is all.

THE SEVEN CHAKRAS RELATED TO ORGANIC VITALITY

Chapter Eight
The Yantric Exercises

It is necessary to know that in our human body, in our cellular organism, we have some chakras that we can qualify as specific, special for our organic vitality. These are like vortexes through which Prana, life, enters into our organism. They are, namely:

- First, the occipital,
- Second, the frontal,
- Third, the laryngeal located at the throat,
- Fourth, the hepatic,
- Fifth, the prostatic [or uterine],
- Sixth and seventh are the two related chakras located at the knees.

So, these are the seven basic chakras [related to organic vitality; there are additional chakras in the organism]; again, these are important for the vitality of our physical organism since through these chakras, the life, Prana, penetrates into our Vital body, which is the seat of all organic activity.

For example, the laryngeal chakra maintains a close relation with the prostatic; this is why what we say, our words, must be carefully weighed. Likewise, we need to carefully avoid making very low or shrieking sounds when we speak; i.e., if we carefully observe decrepit old people, we can easily verify that when they speak they emit sounds that we could perfectly call shrieking; these sounds corrupt their sexual potency, or accurately indicate impotency. The same occurs with sounds that are too deep or cavernous; these also corrupt the sexual potency. Therefore, the male's voice must remain within its normal range; likewise, the woman's voice must not be too low or shrieking, because this corrupts her sexual potency due to the intimate relationship between the larynx and the sexual center.

The former statement could be challenged since the woman does not have a prostate; true, she does not have a prostrate, yet

she has a chakra related to her uterus, and this plays a very important role in her body, as important as the prostatic chakra in the man. In the woman, we could call this chakra the uterine chakra, and we already know the importance of the uterus in the woman.

After this short preamble, and as a matter of information, for the benefit of our Gnostic brothers and sisters we are going to narrate something of great significance.

It so happened that sometime ago in India, lived an English Colonel who was about seventy years old. He was retired from active military service and had a young friend.

The Colonel heard about a monastery of lamas that existed in Tibet where old people become young, in other words, where many who arrived old left young. The method to accomplish this is something that I will transcribe later in a precise manner for all of you. At this moment I only want to explain how these Six Rites make it possible to bring back youth, which was the concern of the English Colonel.

First of all, we must always seek to be in good health, because a healthy body is good for everything, withstands everything, and responds at all moments so that we can demand from it our material and spiritual work.

So, the first thing, as I already stated, is to cure the body and to maintain its resistance throughout our entire lifetime. Therefore, we must maintain it in good condition, because what can one do with a sick body? It is obvious that an esotericist, an initiate, must never be sick; illnesses and tormenting problems are for people who are not on the real path, is it not so? Indeed, those who are on the path should neither be decrepit nor sick, this is clear.

Therefore, this is why there is a series of very important esoteric exercises, i.e. much has been stated in esotericism, in Kundalini Yoga, about the Viparita Karani Mudra, likewise about the Dancing Dervishes or Whirling Dervishes. In Pakistan, in India, etc., the Dervishes know how to execute certain marvelous dances in order to awaken certain faculties, powers, or chakras. Thus, it is urgent to know all of this if we want to

have a youthful body and to develop the chakras. Therefore, let us study this series of exercises.

Young people do not appreciate the value of youth because they are young, yet old people do appreciate the treasure of youth. Thus, with the practices of the Six Rites that we will demonstrate, an old person can rejuvenate; in other words, if the person is old, he or she can recapture their youth. It is clear that if the person is young, he or she can remain young by means of these Rites.

Any person can cure his pains with these exercises; among them, we will show here the Mayurasana; the kneeling position; the table posture that is shown in some sacred ruins, etc.; these are a synthesis of esoteric exercises, documented in India, Persia, Pakistan, Turkey, Yucatan, Mexico, etc.

I have read some of the publications out there; regrettably, they do not teach the fully equilibrated formula as it should necessarily be. Therefore, what I am going to teach to all of you is very important and it must be very well taught in South America and to all the brothers and sisters of the Gnostic Movement, so that old people can become youthful again; Gnostics who are seventy years old can, for example, become as if they were thirty-five or forty years old.

Some will question why I do not look younger. I will answer them that it is simply because I was not interested in preserving this physical body, but now, as I was informed that I could conserve this body for an indefinite time in order to initiate the Age of Aquarius, it is obvious that for this reason I have to practice these exercises.

Sometime ago I read a publication that had these Rites in it; this was sent to me from Costa Rica. Notwithstanding, these Rites are not the exclusive patrimony of anyone. There are some lamaseries in the Himalayas and in other places where these rites are practiced, mainly in a monastery that is called "The Fountain of Youth"; however, even though many exercises are practiced there, I did not find the complete documentation of these exercises in the above-mentioned publication.

I obtained some data from the mentioned monastery, which I know very well, and other data from other schools in India that I also know very well.

When one takes the trouble of traveling a little through Turkey, Persia, Pakistan, etc., then, one can learn something about the Dancing or Whirling Dervishes, etc. We need to reflect a little about what being on one's knees symbolizes, since when one is a child, one unconsciously practices certain exercises.

Now, I am going to continue the very intriguing narration that I read in that publication, which is the very interesting story of that English Colonel that I am going to write in detail so that all of you can have an exact and complete idea about the benefits that are acquired with the exercises that I am teaching here.

In the above-mentioned magazine, they wrote of the case of that seventy-year-old English Colonel, who learned in India of the existence of a monastery in Tibet where people could rejuvenate. He invited a friend to come along with him. Yet, since his friend was young, obviously, he did not listen; the young man would have thought why should he go in search for a place to rejuvenate since he was already young.

On the day of the wretched old-man's departure, his young friend—as is to be expected—laughed a great deal when seeing the wretched seventy year old man with his cane, bald head, a few white hears, very old, traveling towards the Himalayas in search of youth. In the mind of his young friend the following thoughts arose: "How funny is this old man: he already lived his life and wants to live it again." Thus, he saw the old man leaving and the only thing it caused in him was laughter.

Interestingly, after about four months, the Colonel's young friend received a letter from the old man in which he was informed that the Colonel was already on the track of the monastery called "The Fountain of Youth." This, of course, caused only laughter to the young man, thus this subject-matter lingered.

Then, indeed, four years later, something happened which was no longer a laughing matter. Someone presented himself at the house of the young man and knocked at the door. Thus,

the young man opened the door and said, "At your service, what can I do for you?"

The visitor, who appeared to be a man about thirty-five to forty-years old, answered, "I am Colonel so-and-so."

"Ah...," said the young man, "Are you the son of the Colonel who left for the Himalayas?"

The visitor answered, "No! I am the Colonel himself."

The young man answered, "That is not possible; I know the Colonel, he is my friend; he is an old man and you are not old."

The visitor answered, "I repeat: I am the Colonel who wrote you a letter four months after my departure. In it I informed you that I had found the way to the monastery."

Thereafter, the visitor showed his documentation to his young friend; indeed, his young friend was astounded.

What is intriguing about this is that during his time in the Himalayas in that monastery called "The Fountain of Youth," the Colonel saw many youths with whom he established friendships. There was not a single old man in that monastery; everybody was young. He was the only old person; all the others were people between thirty-five and forty years of age. However, after a while, when he had become very good friends with many of them, he discovered that all of them were more than one hundred years old. In other words, all of them surpassed his age, but none of them appeared as an old man. Obviously, the Colonel was astounded, and thus he dedicated himself to the discipline of that monastery and succeeded in re-conquering his youth.

Well, I read the entire story in that publication which they sent me. Nevertheless, I personally know that monastery: I have been there; it is a very large building with immense courtyards. The males work in one courtyard and the female initiates in another. The female initiates in that monastery are not only Tibetan women, but English, French, German, and women from other European countries.

I have known since ancient times all the exercises that are taught in that monastery. I.e.:

- I have long known the whirling movements of the Mohammedans; these dances constitute part of the esoteric aspect of Mohammedanism and are practiced—as I already stated—by the Whirling Dervishes.
- As far as the kneeling position is concerned, that belongs to the special technical movements of esoteric mysticism.
- As for the table posture, this is found in Yucatan.
- As for the position which some call the lizard posture —which is an exercise meant to reduce the abdomen—it is documented in Hindustan, in Kundalini Yoga, and is simply called Mayurasana.
- The laying position with perpendicular legs (upward feet) has abundant documentation. This has always been known as the Viparita Karani Mudra; we find it in many sacred texts.
- Likewise, the famous Vajroli Mudra, which is useful for sexual transmutation for bachelors and bachelorettes; Vajroli Mudra also helps a great deal those who work with the Sahaja Maithuna.

Many publications have been printed concerning this series of exercises, yet they are not the exclusive property of any person, and as I stated, few are those who know the esoteric part of them. I know the esoteric part of them, not merely because of what might be said in the mentioned publication from Costa Rica, or the many others publications that we have read and which have published these exercises, but because I have known them since a very long time ago.

Indeed, I have known these rites practically since Lemuria. For example, I practiced the Viparitha Karani Mudra intensely when I was reincarnated on the continent Mu or Lemuria, thus I practically know how very important this is.

Healing by Means of the Intervention of the Holy Spirit

Let us now enter into the practical aspect of this matter; let us teach to the brothers and sisters of international Gnosticism everything that I deliver from the Patriarchal Headquarters of the Gnostic Movement in the capital city of Mexico. It would please me very much if all of you learn these six rites that I am going to teach.

Indeed, I am going to teach you six rites; understand that these are not merely physical calisthenics, no..! These are RITES practiced by the lamas who work in that monastery called "The Fountain of Youth." They use a prayer rug, which is a small rug on which they perform these rite-exercises; on it they lie down, they kneel, they sit, etc.

Meditation and prayer correspond with each posture or sadhana; in other words, when they change a rite-posture, they intensify their meditation and prayer on any of the mystical aspects, in accordance to what they are beseeching for.

The Divine Mother Kundalini is the central focal point of each sadhana. Thus, when we are performing these exercises, we must be in perfect concentration and prayer; we are beseeching, begging to the Divine Mother for our most urgent necessity. Through Her, we can ask of the Logos; She intercedes for us before the Logos, She pleads with us, She begs for us. She has great power, thus we beg to Her, the Divine Mother, to intercede for us before the Third Logos, so that She may beseech to the Logos for healing, for the awakening of our consciousness, the awakening of any chakra, etc.

Each position is different and each implies an intensification of our prayer, our petition, our pleading, our begging.

In these exercises of meditation, concentration, and pleading, we may very well ask our Divine Mother to invoke, by Her own will, Her divine husband, the Third Logos, the very sacred Holy Spirit. We already know very well that the husband of the Divine Mother is the Holy Spirit.

THE DIVINE MOTHER AS DEPICTED BY CHRISTIANITY

It is necessary to beg and to intensely beseech to our Divine
Mother so that She may, in turn, beg and beseech Her divine
husband to heal us, and to relieve us from any illness or pain
that is afflicting us; this way, She will concentrate in the Logos,
Her husband, the Arch-hierophant or Arch-magus (as He is
named) so that He may come and heal this or that sick organ
that is hindering the rendering of our work.

In these moments, we must identify ourselves as being one
with the Logos, with the Holy Spirit and, in a tremendous, im-
perative way, we command the sick organ saying:

Be Healed! Be Healed! Be Healed!

Work! Work! Work!

We must talk to the organ with true faith, with energy, with courage, since it has to unavoidably be healed.

We must definitely be concentrated on each cell of the sick organ, on each atom, on each molecule, on each electron of the sick organ, and commanding it to work, to be healed, to be cured, while being profoundly concentrated on the Logos, completely identified as being one with the Holy Spirit, who in those moments is performing the cure, the healing of the sick organ. Thus, in this way, the organ will have to be healed, it will have to be cured, this is obvious.

Therefore, it is commendable for each person to learn how to cure himself. Thus, through the strength of the Holy Spirit, we are able to cure ourselves; we are able to cure any illness. This problem of going around sick is very depressing, very painful, and those who walk on the path, as I have already stated, should not have the basis for being sick. So, these exercises develop the chakras and, on the other hand, they heal our organism.

Very important chakras exist, i.e. the one on the occipital, which is a door through which many forces enter into our organism; the frontal is another door through which vital forces penetrate into the organism, when their chakras are developed. The larynx, as I have already stated, has an intimate relationship with the prostatic chakra which is the one related with both sexes, the male and the female; thus, the prostatic/uterine as well as the larynx are very important for the health of our organism. Another is the chakra of the liver: as you know, the liver is a true laboratory; we must develop the hepatic chakra in order for the liver to correctly function because when the liver is functioning well, sequentially the organism also functions well.

Chakras of the knees also exist; there are two, one on each knee, and these are vital for the human body. These vortices of strength must intensively spin in order for life, Prana, health, to enter into the human body.

First Rite

Standing on their feet, the students extend their arms from side to side, forming the shape of a cross. Thereafter, they begin to turn around, to spin their body from left to right clockwise (See figure 1).

It is clear that the chakras will also spin with some intensity while performing this rite-exercise, and after some time of practice.

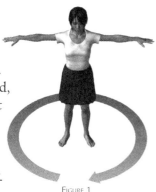

FIGURE 1

Let us imagine that we are standing in the center of a large clock, thus, we spin clockwise, this is, in the same direction of the needles of the clock, until completing twelve turns; it is clear that some will begin with few turns, yet the day will arrive when they will completely perform all the twelve turns.

We must whirl around with the eyes open, yet when we finish our turns, we must close our eyes in order to not fall, since we will be a little woozy according to the number of turns we are be able to perform. Thus, one day we will be able to perform the complete exercise of twelve turns. Students will keep their eyes closed until the dizziness has disappeared.

Meanwhile, they will keep their prayer, their pleading, and imploration to their Divine Mother so that She may plead and beg Her divine husband to grant us the healing of any particular sick organ. The student must be totally identified as being one with the Logos while intensely asking the Divine Mother for Her intervention on behalf of the student before the Logos.

We have to spin clockwise from left to right, because amongst the mediums (chanellers) of spiritualism, their chakras turn counterclockwise, from right to left, meaning in a negative way, and that way is useless. We, Gnostics, are not mediums or anything of the sort. Thus, we must develop our chakras in a positive manner.

Therefore, the system that I am teaching to all of you is marvelous, because it allows the development of the chakras

and the healing of illnesses. All of the following rite-exercises complement each other.

We must start performing the exercise in a practical manner while concentrated on our Divine Mother Kundalini; our feet must be together in military style, firm, arms extended from side to side.

Thereafter we begin to spin from left to right, while intensely asking for what we most need, above all, for the healing of the organ that may be sick, is not it right? Thus, subsequently we may ask for our chakras to spin. It is clear that if we rotate clockwise, from left to right, in the same way as the needles of a clock that is seen, not on you, but in front of your sight, the chakras will rotate positively. Therefore, turn around and around at the rhythm that you consider convenient. Twelve turns is what is mandatory; however, if after you complete twelve, you want to continue up to thousand, well, that is up to you.

During the turnings that we are performing, we must be concentrated on our Divine Mother Kundalini, asking Her to call the Holy Spirit, thus imploring Him to heal us, begging the Logos to cure us. Moreover, we must open the sick organ by pronouncing unto it:

Open Sesame! Open Sesame! Open Sesame!

The former mantra appears in the book *One Thousand and One Nights*. People think that such a book contains, after all, simply very beautiful tales, thus, they do not pay attention to that mantra, nevertheless, "Open Sesame" is an authentic mantra. So, command the organ to open so that the healing vital energy will enter into you through it, thus, this is how the force of the Holy Spirit penetrates into the sick organ. It is clear that the organ becomes healed with the force of the Third Logos. Notwithstanding, we must execute all of this with much faith, much faith, and much faith.

Now, after your spinning exercise has finished, you open your eyes. Lie down on the floor on your back, in other words, facing upwards, legs stretched out with your heels together, your arms also stretched but horizontally, extended from side to side so that you make the form of the cross with your body,

Figure 2

looking upwards towards the ceiling of the house.

Here, you intensify your concentration; you intensify your meditation on the Divine Mother Kundalini, begging Her, imploring Her, to cure the sick organ that you want to heal. Likewise, at that moment, those who are not asking for healing can ask for any other necessity, such as the elimination of any "I," any psychological defect or the development of any psychic power, etc. We have the right to ask, since this is the purpose of these exercises.

Thus, while lying down on your back on the floor, we supplicate and intensify our prayer, our petition, completely identifying ourselves as being one with the Third Logos. Therefore, the second position is to lie on the floor in the shape of a cross. We now know how to supplicate and ask in this position (See figure 2).

Second Rite

You have made your petitions while lying down in the shape of the cross; now raise your legs perpendicularly until they are in a vertical position (See figure 3). Here, it is no longer necessary to keep your arms extended and forming the horizontal line of the cross. So, move them so that with your hands you help to sustain your legs by holding them at the back of your knees, making sure that your legs are as vertical as possible without raising your buttocks from the floor, or more clearly stated, your waist must be very well placed on the floor, resting on the floor.

Figure 3

This is what in the East is called the Viparita Karani Mudra. In this position, all the blood flows towards the head. It is precipitated towards the cranium so that determined areas of the brain can be set to work, likewise in order to fortify the

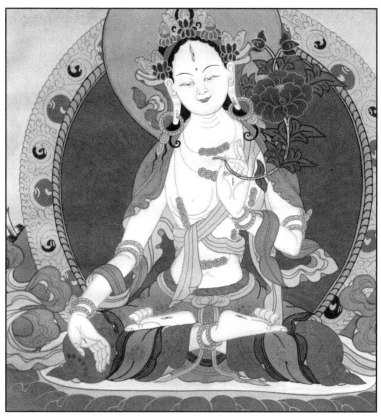

THE DIVINE MOTHER AS DEPICTED BY TIBETAN BUDDHISM

senses, to fortify our eyesight, since it is necessary to have good eyesight, a good sense of smell, touch, hearing, and taste, etc.

We must remain in this posture for some time, while intensifying our petition to our Divine Mother Kundalini, begging her, beseeching her to help us to attain, with the help of her divine spouse, the benefit, the healing, the faculty, the disintegration of any defect, etc., that we need.

Well, after some time with this posture, after having supplicated to the Divine Mother to bring you the Third Logos and after having totally identified yourself as being one with Him so that He may heal you or may awaken a particular faculty, etc., you finish the exercise.

Understand that before anything else, we must go to the practical aspect, since these exercises are also effective for the awakening of our chakras and as I have already stated, through them the Gnostic Arhat can enter the path of the awakening of consciousness. You already know the Dance of the Dervishes, the Viparita Karani Mudra, and the posture of the cross; remember that with our imagination we must open the sick organ by imperatively commanding it:

Open Sesame! Open Sesame! Open Sesame!

Comprehend that in each rite-exercise we must beseech our Divine Mother Kundalini so that She can plead to the Holy Spirit in Her sacred language, thus He can assist us and heal us of this or that sickness, according with the necessities we each have, etc., thus some will ask for healing, others for the awakening of this or that power, others for the annihilation of this or that defect., etc...

Again, these rites are not merely physical aerobics, but six methods of prayer. It is a distinct system of healing and rejuvenation through prayer.

The lamas practice these six rites on a prayer mat; it can be a mat or a carpet or whatever we want to call it. There are so many words and each country has many names in order to name objects or things, and it is clear that one is forced to use different terms so that people may understand.

Naturally, with much patience, slowly, we have to become accustomed to these exercises, thus the day will arrive when we will perform them easily. These are not meant to be done all at once, no!; we must condition our organism slowly, little by little, in order to perform these exercises better until they are performed correctly. As far as conditioning the body is concerned, some may take days, others weeks, other months, others years.

These rite-exercises are not for citizens of a particular country either. They are for all the Gnostic citizens of the world. I do not understand why people are bottled up within that which is called "patriotism." They do not understand that "my country" and "your country" are the same country. People have divided

the earth into parcels and more parcels and have placed a flag on each parcel, and chiseled a few statues for their heroes; they have filled the frontiers with savage hordes who are armed to the teeth, etc. Regrettably, this is what they call "my country." It is very sad that the earth is divided into many parcels. The day in which the Earth will have to change will arrive; unfortunately, such a change on this planet is very difficult; thus, only after the great cataclysm will this planet be converted into one great country... Nevertheless, now let us limit ourselves to the exercises that I am teaching you.

Third Rite

Now, kneel on the floor towards the east, that is, place yourself on your knees, towards where the sun rises and bow down your head a little: only a little, not too much (See figure 4)... afterwards you must perform three Pranayamas as follows:

Pranayama

Shut your left nostril by placing the index finger of your right hand on it, then inhale air through the right nostril; after the inhalation, close both nostrils with the index finger and the thumb; hold your breath for a few seconds, then uncover only your left nostril and exhale all the air through it. Now keep the right nostril shut with your thumb on it while inhaling the air through the opened left nostril, then press both nostrils again with the thumb and index finger. Repeat this exercise two more times until you complete three inhalations and

FIGURE 4

three exhalations through each nostril; understand that these three inhalations and exhalations are equivalent to three complete Pranayamas.

Remember to use only the index finger and the thumb exclusively from the right hand, and that is it. You close one nostril with one finger while inhaling through the opposite nostril, then you close both, and uncover the opposite nostril, etc. It is a back and forth kind of play that you perform from one nostril

to the other, that is, when you close one, you uncover the other and vice versa.

Once you have finished your Pranayamas, lower your head again and enter into prayer to the Divine Mother Kundalini Shakti, beseeching to your Devi Kundalini for what you need, etc.

Now, while in the kneeling position, backwardly incline your body, making an acute angle with it while keeping the kneeling position. Your arms must be kept straight touching the body lengthwise. Incline your body backwardly as far as you can and keep that position for few seconds, while begging, beseeching, imploring to the blessed Mother Kundalini, to intercede for us before the most sacred Holy Spirit so that the benefit we are requesting, whether for healing or any other purpose, can be granted to us.

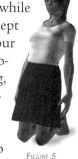

FIGURE 5

This exercise is performed in a considerably short time because it is strong or difficult to execute, yet it is very good in order to make the body more agile and to burn some toxins. What is important is to perform it as best we can. (See figure 5).

Remember very well that in each exercise, it is necessary to beg, to intensely beseech, to even cry if necessary, in order for our Divine Mother to call upon the Third Logos in order to heal any given sick organ for us.

Remember that She is the mediator, the one who can invoke the Logos who is Her divine spouse, the most sacred Holy Spirit, Shiva, as He is called in the East, the Arch-hierophant, the Arch-magi, the First Begotten of Creation, the Swan of living plumage, the white Dove, the immortal Hiram Abiff, the Secret Master, whom we all committed the error in the past of murdering; yes, we murdered him when we committed the original sin. This is why we need to resurrect Him from among the dead, and exclaim with all the forces of our heart: *The King is dead, long live the King!*

THE DIVINE MOTHER AND HER HUSBAND SHIVA AS DEPICTED IN INDIA

Fourth Rite

Now perform the following position: sit on the floor, place your hands backwardly on the floor and stretched your legs so that the trunk of your body that is somewhat backwardly inclined, is resting on your hands, your heels together, yet the tip of your feet opened like a fan, and your head-eyes looking forward (See figure 6). Here, we once again make our petition, our supplication, with much faith and devotion to our Divine Mother.

Now, in order to execute the following exercise, let us bend our legs a little until the soles of our feet are placed on the floor. Then we must elevate our buttocks and our belly or abdomen, so that our body is in the

FIGURE 6

position of a table; our knees, abdomen and face must form one straight, horizontal line.

Our face must remain looking upwardly towards the ceiling of the house. The body must be supported by the hands and the feet, thus forming, as I already stated, a human table (see figure 7). While in this position, we must intensify our imploration and supplication to our blessed Mother Devi Kundalini, asking her to invoke her divine husband, the most sacred Holy Spirit, so that he can come and execute the cure we need. This has been explained to you several times, but it is good to insist upon it so that you do not forget that these rites are not just something physical, they are something different; thus, each exercise needs imploration and supplication in order to be complete. Understand that exercise and supplication must be equilibrated.

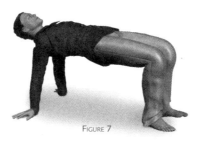

FIGURE 7

Repeat the Pranayama

Before studying the rite-exercise called Mayurasana, let us now repeat exercise #4, but here it will be number 8. So, it is necessary to perform again three Pranayamas. I repeat, these are already explained in exercise #4.

Then, after having performed the three Pranayamas (which at this point will be exercise #8), we place our body in the position of a lizard; this is why Mayurasana is also called the posture of the Lizard (See figure 8).

Fifth Rite

Many people used to practice the Lizard posture, precisely in order to eliminate their bulging abdomen, in other words,

what we call the belly, or that horribly inflated and unhealthy abdomen filled with fat.

The ninth exercise is performed by executing motion between two positions:

FIRST Position: hold the body like a Lizard as follows: hold your body up with straight arms by placing the palms of your hands on the floor; stretch your legs back and straight, and sustain the rest of your body on your feet, your tiptoes, with your face looking forward. The back, neck, buttocks, legs, and heels must maintain a straight line, just like a Lizard. (See figure 8).

SECOND Position: while keeping your arms and legs straight, lower your head, tuck it to your chest as much as you can, and lower the knees, legs and abdomen. Thereafter, repeat this movement: downwards, upwards, downwards, upwards, etc. (See figure 9).

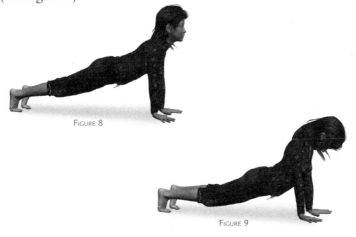

FIGURE 8

FIGURE 9

Here, we implore to our Divine Mother to activate all of our chakras.

When lowering the head and tucking it below the chest as much as we can, we must also lower the knees, legs and abdomen together, without moving the hands and feet from their initial position, then we rise to the position of the eight exercise, then we lower to the position of the ninth exercise, up and down, up and down, etc...

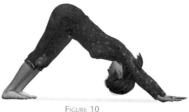

FIGURE 10

From the ninth position of the Lizard, where we have our head well tucked under our chest, without moving our hands and keeping our arms in a straight position and keeping our head well tucked underneath our chest as much as we can, with straight legs, we advance few short steps forward, until our body becomes a human arc. (See figure 10).

Resting on our hands and feet and with the head well tucked underneath our chest, forming a perfect human arc, we must enter into prayer, asking, begging, beseeching, as I have already taught you, to our Divine Mother for what we most need; underneath your body cars and carriages can pass through, since it is forming a type of human arc.

Now, after having prayed for a while in the arc position, we bend our knees a little in order to lower our body, and then lift our hands from the floor; we get up, in other words. We stand straight up on our feet, thus finishing with the exercise.

Remember that with this position of the human arc, just as we have shown it, we make the blood to rush towards the head and the lymph to cleanse and irrigate all the cranial zones.

All of these are very special exercises that help to terminate with the belly or paunch; I do not know why people love to maintain their bulging stomachs filled with fat: ironically they call it "the curve of happiness." We must never have our stomach filled with fat. Understand that with this exercise, we say goodbye to our potbelly.

Viparita Karani Mudra

Now let us learn the Viparita Karani Mudra in a special manner in order to rejuvenate the body. The Viparita Karani Mudra as an eleventh exercise is as follows: Lie down on your back on the floor with your buttocks and legs against a wall, that is, raise your legs and place them in a vertical position against a wall. For this posture place your buttocks and legs very close to the wall while your lower and upper back rests on the floor; hands and arms rest on the floor parallel to the body. (See figure 11)

This exercise is special in order to perform a great work that can only be executed by the most sacred Holy Spirit, within our organism.

In our brain we have a moon that makes us the most lunar beings in this world; thus, for the reason that the moon is in our brain, our actions are negative and lunar. On the other hand, we have a marvelous sun in the umbilical region (solar plexus). Thus, from the time we exited paradise, the luminous sun that was in the brain was transferred to the umbilical region (solar plexus) and the cold moon went up to the brain.

Therefore, understanding that we have this alteration in our organism, while we lie down in that position, we beg to the most sacred Holy Spirit to execute a transplantation within us: that is, to transfer the moon from our brain and to settle it in our umbilical region, and to simultaneously transfer the luminous sun from our umbilical region (solar plexus) and to settle it in our brain.

It is clear that it is essential to practice the Viparita Karani Mudra incessantly, constantly, permanently, just as we are showing it, and to beg, plead, beseech the Holy Spirit to grant us the grace of making this mutation, that is, to place the moon that we have in our brain in our umbilical region and to transfer the sun that we have in our umbilical region to our brain.

FIGURE 11

This is a labor that only the Third Logos can perform, and the Viparita Karani Mudra is the precise, necessary posture for it. We must profoundly implore and beseech, while concentrating on the Third Logos, so that He may come and perform the transplantation of the moon to the umbilical region and the sun to the brain.

This Viparita Karani Mudra is a truly marvelous rite in order to attain the rejuvenation of the physical body. To re-conquer everlasting youth is urgent and necessary, since the body should remain young and vigorous in any initiate who marches upon the Path of the Razor's Edge.

Whosoever achieves the performance of the Viparita Karani Mudra straight for three hours will defeat death and will re-conquer everlasting youth. Nevertheless, we must begin by performing for no more than five minutes at a time, and thereafter we increase the time gradually, slowly, patiently; for instance, increase it by one minute daily.

For those who aspire for the rejuvenation of their body and for the healing of all sickness, here we give them this marvelous formula: the Viparita Karani Mudra. Understood?

So, in the Viparita Karani Mudra we ask the Third Logos for the rejuvenation of our physical organism or to heal us from any malady or sickness, to replace the old cells for new cells, etc. Start with five minutes and add progressively one minute every day until reaching the maximum of three hours. It is evident that in order to achieve the three hours, a long time is necessary, maybe several years of constant practice, yet those years of constant practice are equivalent to defeating death by means of the famous Viparita Karani Mudra.

> *The esoteric Viparita Karani teaches scientifically how the Hindu yogi, instead of ejaculating his semen, raises it slowly through concentration in such a way that a man and woman can eliminate the animal ego while united sexually. The esoteric Viparita Karani teaches how, through concentration, the "yogi slowly raises the semen, in such a way that man and woman can attain Vajroli. As stated in the Viparita Karani: "This practice is the most excellent one, the cause of liberation for*

the yogi; this practice brings health to a yogi and grants him perfection." - The Mystery of the Golden Blossom

Sixth Rite

VAJROLI MUDRA: TRANSMUTATION FOR BACHELORS AND BACHELORETTES

We are now entering into the study of the sixth rite that is precisely the Vajroli Mudra, which is the rite related with the transmutation of the sexual energy, which is the finest type of energy that is generated by the physical organism; it is, better said, the subtlest force with which the human body works.

The human vehicle has certain very fine channels through which the sexual energy circulates; this energy cannot circulate through other channels, because when the sexual energy bursts into other channels, it is clear that a catastrophe takes place. The sexual energy is a wonderful, explosive force that we must learn how to direct wisely, if we truly want the inner realization of the Being.

Indubitably, the Vajroli Mudra is a very special rite for bachelors and bachelorettes, even though it can also aid married people. Specifically, we can say that with the Vajroli Mudra the bachelors and bachelorettes have a fundamental system in order to sustain themselves in Brahmacharya—that is, in chastity.

Man and women who do not have spouse must sustain themselves in Brahmacharya—of course, until the day in which the bachelor acquires his priestess and the bachelorette her husband.

Many bachelors and bachelorettes would like to fulfill their sexual functions here, there, and everywhere with different partners—that is, to fornicate—yet, that is prohibited for the aspirants to the Adepthood. Bachelors and bachelorettes who truly aspire to reach the Adepthood cannot mix sexually with different partners, because by doing so they violate the Law—that is, they break the Sixth Commandment of the Law of God.

Celibates must firmly maintain themselves in Brahmacharya until their spouse arrives to them, and it is not possible for them to maintain their Brahmacharya if they do not know how to transmute their sexual energy.

Whosoever wants to learn how to transmute the sexual energy must know in depth the Vajroli Mudra, since if they do not know it, they do not know, because they do not have the science for sexual transmutation.

Vajroli Mudra has—among other things—an advantage especially for bachelors, in spite of being unmarried, to preserve their sexual potency—that is, not to lose their virility. Normally, an organ that is not used becomes atrophied; if one ceases to use one hand, then that hand becomes atrophied; if one ceases to use a foot, then that foot does not work anymore. Likewise, if one ceases to use one's creative organs, then they simply become atrophied and the man becomes impotent; then, such a man is already marching with a deficiency.

Fortunately, with the Vajroli Mudra bachelors can preserve their sexual potency for their entire life. However, I am not saying, and I clarify this, that an individual can create the superior existential bodies of the Being with the Vajroli Mudra; no! I am not making these types of affirmations. Neither am I stating that with the Vajroli Mudra one can attain the inner realization of the Being. Whosoever wants to attain inner realization has to work in the Forge of the Cyclops—this is clear.

It so happens that with the Vajroli Mudra one is only working with a single force; in the case of the man, he works with the masculine force, and in the case of the woman, with the feminine force, and nothing else. In order to create the superior existential bodies of the Being, something more is necessary; it is required to work with the three forces of nature and the cosmos: the masculine force (in the man), the feminine force (in the woman), and the neutral force (that in the sexual act conciliates the masculine and feminine). As I have already stated, the masculine force is the Holy Affirmation, the feminine force is the Holy Negation, and the neutral force is the Holy Conciliation. It is clear that in order for creation to occur the three forces are

necessary; this is why the Sahaja Maithuna is indispensable in order to create the superior existential bodies of the Being.

Common and ordinary people do not have the astral, mental, and causal bodies because such bodies have to be created, and they can only be created by means of the Sahaja Maithuna or Sexual Magic. Nevertheless, I repeat, the Vajroli Mudra serves the bachelors since they do not have wife, and bachelorettes since they do not have a husband, and it also helps the couples that are working with the Sahaja Maithuna, because it helps them to sublimate and transmute their sexual energy. Therefore, the Vajroli Mudra is very useful for bachelors and bachelorettes and for married couples. Well, now after this explanation, I am going to teach the technique of the Vajroli Mudra.

Standing in a steady position, looking forward, place your hands on your waist with your thumbs towards your lower back—thus making with your arms the shape of a jar's handles—then inhale air until totally filling the lungs. Next, put the palms of your hands on top of your thighs and incline your body forward—not towards the sides nor backwards, but forward as when one is assuming a reclining position or making a profound prostration—thus, continue lowering the palms of your hands little by little until reaching your knees. As you bend, simultaneously you must exhale the air, so that when you are already touching your knees your lungs are completely empty of air.

Once in the leaning position, we are prepared to continue the sequence of the exercise. Here, still, we have not inhaled the air: our lungs are completely empty. Now, we continue the exercise by raising the hands in the direction of the creative organs—yet, we must not fill the lungs with air—now we perform a massage on the prostate, so that the vibration touches the prostate and the transmutation of the sexual energy is performed; we must perform a massage not only on the prostate, but we must also perform a massage with firmness upon the sexual organs. Then, as soon as we perform the massage over the creative organs, we must slowly raise the body to an upright position; thus, we straighten the body while our feet remain united and firm on the floor. Now, with the body straight, we place the

hands on the waist, thus with the arms making again the shape of a jar's handles.

Once we have performed the massage and have placed the hands on the waist, we inhale until filling our lungs with air, and sublimate the sexual energy to the brain through the channels Ida and Pingala. Then, we exhale slowly and repeat the same procedure three times.

Regarding the massages over the prostate/uterus and the sexual organs, there are three types:

a) Gentle massage upon the prostate and creative organs.

b) Moderate massage upon the prostate/uterus and creative organs.

c) Strong massage upon the prostate and creative organs.

It is obvious that for men a strong massage on the prostate and sexual organs produces the erection of the phallus, this is clear, this is how it is; this is why the third type of massage is advisable for bachelors. Thus, when the phallus is erected, the transmutation of the semen into energy is produced, which one raises to the brain.

Regarding married men, the first or second types of massages are convenient for them, nothing else; rather, the first type is more than enough since they have a wife and of course they bring the phallus to a complete erection by means of the Sahaja Maithuna.

So, here I have taught you what in the East they call Vajroli Mudra.

In the case of women, the Vajroli Mudra is the same, with the difference that women must perform the massages over their left and right ovaries and over their feminine organs—to be more precise, over the vagina or Yoni. This is how the transmutation of the sexual energy takes place in women.

The same applies to the married woman, although she does not need a strong massage, only a soft one; bachelorettes need a little stronger massage in order to produce the transmutation

of their sexual energy; it is necessary that that energy raises to the brain.

Therefore, it is necessary to have a great force of willpower during the Vajroli Mudra; no lustful thought must cross the mind of the student. It is necessary to control the senses; it is necessary to subjugate the mind.

When one practices the Vajroli Mudra, one needs to be concentrated on the Divine Mother Kundalini, or on the Third Logos. If one is concentrated exclusively on the sexual organs and forgets the Divine Mother and the Third Logos, then one does not sublimate the sexual energy, and one goes against the Cosmic Law.

Moreover, take into account that if the human being does not have enough purity in his thoughts, he can degenerate himself and become a masturbator. For the impure and masturbators will be the abyss and the second death, where only weeping and gnashing of teeth are heard.

Therefore, the Vajroli Mudra is for completely chaste men and women who truly are willing to follow the path of absolute chastity.

The strong—very strong—Vajroli Mudra can only be practiced once a day, and for this it is necessary for the individual to be very serious and respectful of their own body; this for bachelors and bachelorettes, since a married man does not need to practice a strong Vajroli, because he attains erection with his priestess wife. Likewise, a woman who has a husband does not need to practice strong Vajroli, because she transmutes her energies with her husband. Therefore, married couples must perform extremely soft massages during the practices of Vajroli; what one is aiming is to elevate that subtle and delicate creative energy to the brain.

In the case of a married man, it is enough, as I already stated, for a slight massage on the prostate and sexual organs; likewise for the married woman, a slight massage on the ovaries and the uterus. A very subtle and smooth massage does no harm in any way, thus it is possible to practice a slight massage whenever we work with the six rites taught in this book, without the smaller

damage. Thus, this is how the sexual energy is constantly, incessantly sublimated, and used for our regeneration.

I am therefore, speaking in a very clear manner so that you can understand me. This system as I have taught it to you here is the Tibetan system. I repeat that it is necessary to perform it with purity and without lust, nor evil, passional thoughts; otherwise, if the students misuse these teachings, then the sword's edge turns against them and they can tumble into the abyss.

So, I believe that the Gnostic brothers and sisters have understood the purpose of the Vajroli Mudra. Again, I am not tired of repeating that this is the most practical and precise system of sexual transmutation for bachelors and bachelorettes.

After teaching the practice of Vajroli Mudra, I must state the following: The fatal antithesis of the Vajroli Mudra is the horrifying, impure, and abominable vice of masturbation. Those who practice masturbation sink into the abyss in order to suffer the second death, because of the crime of having had profaned their own body, because of having—with their perverted deeds—insulted and profaned the Holt Spirit, the Third Logos.

Therefore, be very careful, brothers and sisters who practice the Vajroli Mudra, of not falling into the abominable and repugnant vice of masturbation. The Vajroli Mudra is something very holy, very sacred; a tremendous chastity, a great sanctity, an enormous love to the very Sacred Holy Spirit and the Divine Mother Kundalini are required in order to practice it.

I must also clarify that I am not stating here that with the Vajroli Mudra one is going to awaken the Kundalini, or that one can create the superior existential bodies of the Being; no! The Vajroli Mudra only transmutes the semen into energy, and that is all.

It is already clear that in order to awaken the Kundalini it is necessary to have the cooperation of the three forces of nature and the cosmos, as we already stated, but it is worthwhile to remember it once again so that you may record it very well in your minds. The first force is the Holy Affirmation, the second force is the Holy Negation, and the third force is the Holy Concilia-

tion; the latter unites and conciliates the other two. Therefore, the Kundalini can only be developed by means of Sexual Magic or Sahaja Maithuna—in other words, with the cooperation of the three forces. The man has the positive force, the woman has the negative force, and the Holy Spirit conciliates both; thus, the Divine Princess Kundalini awakens with the fusion of the three forces.

The superior existential bodies of the Being cannot be created with a solitary force. The man has one force: this is the Holy Affirmation. The woman only has the negative force: this is, the Holy Negation. It is only possible to perform creation with the union of the three forces: the positive or masculine, the negative or feminine, and the neutral that coordinates and mixes both.

Transmutation is always indispensable, since it is an organic and fundamental necessity.

Well, it was necessary to have spoken clearly on this aspect, since the Vajroli Mudra—which is a marvelous system for transmutation for bachelors and bachelorettes—is practiced, for instance, in India, in Tibet, and in that monastery named "the Spring of Eternal Youth."

So, the objective of this system is to elevate the creative energy to the brain. In other words, this is how we seminally nourish the brain and this is how we cerebrally nourish the semen.

Inverential Peace

Samael Aun Weor

Editor's Epilogue: Vajroli Mudra

Readers may also be surprised to discover that the Vajroli Mudra technique taught by Samael Aun Weor does not correspond to the versions known by afficianados of Eastern mysticism. It is in the interest of the student to meditate on the disparity, and consider well how reliable and sincere a source of knowledge the general public (or even the so-called experts in Tantra) may be, especially those who make their living from their "expertise." One such popular technique, taught widely in many different schools of Tantra, is briefly described below by Samael Aun Weor:

> "It causes us great horror to know that the tenebrous black magicians of the Drukpa clan (those who are dedicated to the fatal and horrible black tantrism) ejaculate the seminal liquor during their practices of black magic. These black magicians have a fatal technique that enables them to reabsorb the spilled semen. Such a technique is known as black vajroli. This practice is completely negative; therefore we do not even want to explain the procedure. We know that there exist many people with very weak mentalities, who could easily be led into practicing such horrible black tantrism. Karma would then fatally fall upon us. The spilled semen is mixed with feminine "verya" (feminine semen) and afterwards it is re-absorbed. Thus, it is horribly recharged with atoms of the secret enemy. These are satanic atoms that are collected from the atomic infernos of the human being. The inevitable result of this black tantrism is the descent of the serpent towards the atomic abyss of Nature. This is how the human personality ends. It is definitely disconnected from its Divine Spirit. The human being is then transformed into a demon.

> "The Arcanum A.Z.F. (Urdhvarata) was practiced within the ashrams of ancient India. At that time, yogis were prepared for sexual magic with the white vajroli. Unfor-

tunately, the brothers and sisters of the temple com-
mitted scandalous acts, which discredited sexual magic.
The Gurujis then pulled the curtains of esoterism shut,
and the Arcanum A.Z.F. was forbidden." - Samael Aun
Weor, *The Yellow Book*

Obviously, the Vajroli Mudra technique taught in this book
belongs to the Tantra of chastity and is directly opposed to the
Vajrolis taught in the Tantric schools of fornication, whether
in the East or the West, and which are very popular and wide-
spread in these dark times.

Glossary

Astral: This term is dervied from "pertaining to or proceeding from the stars," but in the esoteric knowledge it refers to the emotional aspect of the fifth dimension, which in Hebrew is called Hod.

Chakra: (Sanskrit) Literally, "wheel." The chakras are subtle centers of energetic transformation. There are hundreds of chakras in our hidden physiology, but seven primary ones related to the awakening of consciousness. "The chakras are points of connection through which the divine energy circulates from one to another vehicle of the human being." - *Aztec Christic Magic*

Chambers: In Universal Gnosticism, there are three levels of help and instruction. First Chamber is the public, introductory teaching. Second Chamber is for those who have committed themselves to Gnosis and the death of the ego. Second Chamber is kept secret as it is a sacred and profound trust. Third Chamber is an even more advanced level of help, which is also kept Hermetically Sealed. These Three Chambers reflect the universal nature of all true Initiatic Colleges: in Masonry the initiates of each level were called (1) Apprentice, (2) Journeyman or Craftsman, and (3) Master. In Tibet, the same system is preserved. It is important to note that Samael Aun Weor emphasized the necessity for the Three Chamber system and any school that does not maintain this structure is lacking the connection to the Logos Samael. Only those Institutions who maintain the Chambers can be said to be true Gnostic Schools, wherever they may be. "We are therefore working, my dear brethren, to initiate the Era of Aquarius. We are working in order to save what is possible, meaning, those who allow themselves to be saved. This is why it is necessary that we shape our Gnostic Movements and that we organize them each time better; that we establish the Three Chambers. Our Gnostic Movements must have exactly Three Chambers. Each Lumisial must have Three Chambers for the instruction of our students. Our Gnostic Centers receive a name in a very pure language that flows like a river of gold that runs under the thick jungle of the sun; that name is LUMISIALS." - Samael Aun Weor, from a lecture entitled *The Final Catastrophe and the Extraterrestrials*

Causa Causarum: (Latin) "Cause of causes."

Consciousness: "Wherever there is life, there exists the Consciousness. Consciousness is inherent to life as humidity is inherent to water." - *Fundamental Notions of Endocrinology and Criminology.* From various

dictionaries: 1. The state of being conscious; knowledge of one's own existence, condition, sensations, mental operations, acts, etc. 2. Immediate knowledge or perception of the presence of any object, state, or sensation. 3. An alert cognitive state in which you are aware of yourself and your situation. In Universal Gnosticism, the range of potential consciousness is allegorized in the Ladder of Jacob, upon which the angels ascend and descend. Thus there are higher and lower levels of consciousness, from the level of demons at the bottom, to highly realized angels in the heights. "It is vital to understand and develop the conviction that consciousness has the potential to increase to an infinite degree." - the 14th Dalai Lama. "Light and consciousness are two phenomena of the same thing; to a lesser degree of consciousness, corresponds a lesser degree of light; to a greater degree of consciousness, a greater degree of light." - *The Esoteric Treatise of Hermetic Astrology (Astrotheurgy)*. "Wherever there is light, there is consciousness." - *The Great Rebellion*

Divine Mother: "Among the Aztecs, she was known as Tonantzin, among the Greeks as chaste Diana. In Egypt she was Isis, the Divine Mother, whose veil no mortal has lifted. There is no doubt at all that esoteric Christianity has never forsaken the worship of the Divine Mother Kundalini. Obviously she is Marah, or better said, RAM-IO, MARY. What orthodox religions did not specify, at least with regard to the exoteric or public circle, is the aspect of Isis in her individual human form. Clearly, it was taught only in secret to the Initiates that this Divine Mother exists individually within each human being. It cannot be emphasized enough that Mother-God, Rhea, Cybele, Adonia, or whatever we wish to call her, is a variant of our own individual Being in the here and now. Stated explicitly, each of us has our own particular, individual Divine Mother." - The Great Rebellion. "Devi Kundalini, the Consecrated Queen of Shiva, our personal Divine Cosmic Individual Mother, assumes five transcendental Mystic aspects in every creature, which we must enumerate:

1. The unmanifested Prakriti

2. The chaste Diana, Isis, Tonantzin, Maria or better said Ram-Io

3. The terrible Hekate, Persephone, Coatlicue, queen of the infemos and death; terror of love and law

4. The special individual Mother Nature, creator and architect of our physical organism

5. The Elemental Enchantress to whom we owe every vital impulse, every instinct." - *The Mystery of the Golden Blossom*

Ego: The multiplicity of contradictory psychological elements that we have inside are in their sum the "ego." Each one is also called "an ego" or an "I." Every ego is a psychological defect which produces suffering. The ego is three (related to our Three Brains or three centers of psychological processing), seven (capital sins) and legion (in their infinite combinations). "The ego is the root of ignorance and pain." - *The Esoteric Treatise of Hermetic Astrology (Astrotheurgy)*. "The Being and the ego are incompatible. The Being and the ego are like water and oil. They can never be mixed... The annihilation of the psychic aggregates (egos) can be made possible only by radically comprehending our errors through meditation and by the evident Self-reflection of the Being." - *The Pistis Sophia Unveiled*

Essence: "Without question the Essence, or Consciousness, which is the same thing, sleeps deeply... The Essence in itself is very beautiful. It came from above, from the stars. Lamentably, it is smothered deep within all these "I's" we carry inside. By contrast, the Essence can retrace its steps, return to the point of origin, go back to the stars, but first it must liberate itself from its evil companions, who have trapped it within the slums of perdition. Human beings have three percent free Essence, and the other ninety-seven percent is imprisoned within the "I's." - *The Great Rebellion*. "A percentage of psychic Essence is liberated when a defect is disintegrated. Thus, the psychic Essence which is bottled up within our defects will be completely liberated when we disintegrate each and every one of our false values, in other words, our defects. Thus, the radical transformation of ourselves will occur when the totality of our Essence is liberated. Then, in that precise moment, the eternal values of the Being will express themselves through us. Unquestionably, this would be marvelous not only for us, but also for all of humanity." - *The Revolution of the Dialectic*. Also known as the Buddha Nature, Buddhata, or Tathagatagarbha.

Heptaparaparshinokh: The Law of 7; The Law of Organization. This law is visible in the seven notes of the western musical scale, the seven chakras, the seven bodies of the soul, the Seven Spirits before the Throne, etc.

Holy Spirit: "The Holy Spirit is the Fire of Pentecost or the fire of the Holy Spirit called Kundalini by the Hindus, the Igneous Serpent of our Magical Powers, Holy Fire symbolized by Gold..." - *The Perfect Matrimony*. "It has been said in *The Divine Comedy* with complete clarity that the Holy Spirit is the husband of the Divine Mother. Therefore, the Holy Spirit unfolds himself into his wife, into the Shakti of the Hindus. This must be known and understood. Some, when they see that the Third Logos is unfolded into the Divine Mother Kundalini,

or Shakti, She that has many names, have believed that the Holy Spirit is feminine, and they have been mistaken. The Holy Spirit is masculine, but when He unfolds Himself into She, then the first ineffable Divine Couple is formed, the Creator Elohim, the Kabir, or Great Priest, the Ruach Elohim, that in accordance to Moses, cultivated the waters in the beginning of the world." - *Tarot and Kabbalah*. "The Primitive Gnostic Christians worshipped the lamb, the fish and the white dove as symbols of the Holy Spirit." - *The Perfect Matrimony*

Human Being: According to Gnostic Anthropology, a true Human Being is an individual who has conquered the animal nature within and has thus created the Soul, the Mercabah of the Kabbalists, the Sahu of the Egyptians, the To Soma Heliakon of the Greeks: this is "the Body of Gold of the Solar Man." A true Human Being is one with the Monad, the Inner Spirit. A true Human Being has reconquered the innocence and perfection of Eden, and has become what Adam was intended to be: a King of Nature, having power over Nature. The Intellectual Animal, however, is controlled by nature, and thus is not a true Human Being. Examples of true Human Beings are all those great saints of all ages and cultures: Jesus, Moses, Mohammed, Krishna, and many others whose names were never known by the public.

Innermost: "Our real Being is of a universal nature. Our real Being is neither a kind of superior nor inferior "I." Our real Being is impersonal, universal, divine. He transcends every concept of "I," me, myself, ego, etc., etc." - *The Perfect Matrimony*. Also known as Atman, the Spirit, Chesed, our own individual interior divine Father. "The Innermost is the ardent flame of Horeb. In accordance with Moses, the Innermost is the Ruach Elohim (the Spirit of God) who sowed the waters in the beginning of the world. He is the Sun King, our Divine Monad, the Alter-Ego of Cicerone." - *The Revolution of Beelzebub*

Intellectual Animal: When the Intelligent Principle, the Monad, sends its spark of consciousness into Nature, that spark, the anima, enters into manifestation as a simple mineral. Gradually, over millions of years, the anima gathers experience and evolves up the chain of life until it perfects itself in the level of the mineral kingdom. It then graduates into the plant kingdom, and subsequently into the animal kingdom. With each ascension the spark receives new capacities and higher grades of complexity. In the animal kingdom it learns procreation by ejaculation. When that animal intelligence enters into the human kingdom, it receives a new capacity: reasoning, the intellect; it is now an anima with intellect: an Intellectual Animal.

That spark must then perfect itself in the human kingdom in order to become a complete and perfect Human Being, an entity that has conquered and transcended everything that belongs to the lower kingdoms. Unfortunately, very few Intellectual Animals perfect themselves; most remain enslaved by their animal nature, and thus are reabsorbed by Nature, a process belonging to the devolving side of life and called by all the great religions "Hell" or the Second Death.

Kundalini: "Kundalini is a compound word: Kunda reminds us of the abominable "Kundabuffer organ," and lini is an Atlantean term meaning termination. Kundalini means "the termination of the abominable Kundabuffer organ." In this case, it is imperative not to confuse Kundalini with Kundabuffer." - *The Great Rebellion*. These two forces, one positive and ascending, and one negative and descending, are symbolized in the Bible in the Book of Numbers (the story of the Serpent of Brass). The Kundalini is "The power of life."- from the Theosophical Glossary. The Sexual Fire that is at the base of all life. "The ascent of the Kundalini along the spinal cord is achieved very slowly in accordance with the merits of the heart. The fires of the heart control the miraculous development of the Sacred Serpent. Devi Kundalini is not something mechanical as many suppose; the Igneous Serpent is only awakened with genuine Love between husband and wife, and it will never rise up along the medullar canal of adulterers."- *The Mystery of the Golden Blossom*. "The decisive factor in the progress, development and evolution of the Kundalini is ethics." - *The Revolution of Beelzebub*. "Until not too long ago, the majority of spiritualists believed that on awakening the Kundalini, the latter instantaneously rose to the head and the initiate was automatically united with his Innermost or Internal God, instantly, and converted into Mahatma. How comfortable! How comfortably all these theosophists, Rosicrucians and spiritualists, etc., imagined High Initiation." - *The Zodiacal Course*. There are seven bodies of the Being. "Each body has its "cerebrospinal" nervous system, its medulla and Kundalini. Each body is a complete organism. There are, therefore, seven bodies, seven medullae and seven Kundalinis. The ascension of each of the seven Kundalinis is slow and difficult. Each canyon or vertebra represents determined occult powers and this is why the conquest of each canyon undergoes terrible tests." - *The Zodiacal Course*

Litelantes: An initiate and spouse of Samael Aun Weor.

Logos: (Greek, "word") In Greek and Hebrew metaphysics, the unifying principle of the world. The Logos is the manifested deity of every nation and people; the outward expression or the effect of the cause which is ever concealed. (Speech is the "logos" of thought). The Logos

has three aspects, known universally as the Trinity or Trimurti. The First Logos is the Father, Brahma. The Second Logos is the Son, Vishnu. The Third Logos is the Holy Spirit, Shiva. One who incarnates the Logos becomes a Logos. "The Logos is not an individual. The Logos is an army of ineffable beings." - *Endocrinology & Criminology*

Mantra: (Sanskrit, literally "mind protection") A sacred word or sound. The use of sacred words and sounds is universal throughout all religions and mystical traditions, because the root of all creation is in the Great Breath or the Word, the Logos. "In the beginning was the Word..."

Maya: (Sanskrit) Can indicate 1) the illusory nature of existence, 2) the womb of the Divine Mother, or 3) the Divine Mother Herself.

Okidanokh: The primary emanation of the Ain Soph, the Solar Absolute. The energy field origin of all the cosmoses and whose vibration manifests through the Law of Three within all dimensional material manifestations. Okidanokh is the fundamental cause of all cosmic phenomena; it is the Christic substance capable of penetrating all cosmic formations. Kabbalistically, it is the life source of the sacred Triamazikamno or Logoic Trimurti: Kether, Chokmah, Binah.

Pranayama: (Sanskrit for "restraint (ayama) of prana (energy, life force)") A type of breathing exercise which transforms the life force (sexual energy) of the practitioner. "Pranayama is a system of sexual transmutation for single persons." - *The Yellow Book.*

Samadhi: (Sanskrit) Literally means "union" or "combination" and its Tibetan equivilent means "adhering to that which is profound and definitive," or ting nge dzin, meaning "To hold unwaveringly, so there is no movement." Related terms include satori, ecstasy, manteia, etc. Samadhi is a state of consciousness. In the west, the term is used to describe an ecstatic state of consciousness in which the Essence escapes the painful limitations of the mind (the "I") and therefore experiences what is real: the Being, the Great Reality. There are many levels of Samadhi. In the sutras and tantras the term Samadhi has a much broader application whose precise interpretation depends upon which school and teaching is using it. "Ecstasy is not a nebulous state, but a transcendental state of wonderment, which is associated with perfect mental clarity." - *The Elimination of Satan's Tail*

Second Death: The complete dissolution of the ego in the infernal regions of nature, which in the end (after unimaginable quantities of suffering) purifies the Essence of all sin (karma) so that it may try again to reach the Self-realization of the Being. *"He that overcometh (the sexual passion) shall inherit all things; and I will be his God (I will incarnate*

myself within him), and he shall be my son (because he is a Christified one), But the fearful (the tenebrous, cowards, unbelievers), and unbelieving, and the abominable, and murderers, and whoremongers, and sorcerers, and idolaters, and all liars, shall have their part in the lake which burneth with fire and brimstone: which is the second death." (Revelation 21) This lake which burns with fire and brimstone is the lake of carnal passion. This lake is related with the lower animal depths of the human being and its atomic region is the abyss. The tenebrous slowly disintegrate themselves within the abyss until they die. This is the second death." - *The Aquarian Message.* "When the bridge called "Antakarana," which communicates the divine triad with its "inferior essence", is broken, the inferior essence (trapped into the ego) is left separated and is sunk into the abyss of destructive forces, where it (its ego) disintegrates little by little. This is the Second Death of which the Apocalypse speaks; this is the state of consciousness called "Avitchi." - from *The Zodiacal Course.* " The Second Death is really painful. The ego feels as if it has been divided in different parts, the fingers fall off, its arms, its legs. It suffers through a tremendous breakdown." - from the lecture *The Mysteries of Life and Death*

Semen: The sexual energy of any creature or entity. In Gnosis, "semen" is a term used for the sexual energy of both masculine and feminine bodies.

Shakti: (Sanskrit, literally "force, power, energy") Symbolized as the wife of Shiva, the Third Logos, the sephirah Binah. The feminine aspect of Binah. A personification of primal energy. Symbolized by a yoni, a female sexual organ.

Shiva: The Hindu Creator and Destroyer, the third aspect of the Trimurti (Brahma, Vishnu, Shiva). The Third Logos. The Holy Spirit. The Sexual Force. The Sephira Binah. Symbolized by a Linga / lingum, a male sexual organ.

Tantra: Sanskrit for "continuum" or "unbroken stream." This refers first (1) to the continuum of vital energy that sustains all existence, and second (2) to the class of knowledge and practices that harnesses that vital energy, thereby transforming the practitioner. There are many schools of Tantrism, but they can be classified in three types: White, Grey and Black. Tantra has long been known in the West as Alchemy. "In the view of Tantra, the body's vital energies are the vehicles of the mind. When the vital energies are pure and subtle, one's state of mind will be accordingly affected. By transforming these bodily energies we transform the state of consciousness." -The 14th Dalai Lama

White Brotherhood: That ancient collection of pure souls who maintain the highest and most sacred of sciences: White Magic or White Tantrism. It is called White due to its purity and cleanliness. This "Brotherhood" or "Lodge" includes human beings of the highest order from every race, culture, creed and religion, and of both sexes.

Index

To learn more about Gnosis, visit gnosticteachings.org

Glorian Publishing (formerly Thelema Press) is a non-profit publisher dedicated to spreading the sacred universal doctrine to suffering humanity. All of our works are made possible by the kindness and generosity of sponsors. If you would like to make a tax-deductible donation, you may send it to the address below, or visit our website for other alternatives. If you would like to sponsor the publication of a book, please contact us at 212-501-6106 or help@gnosticteachings.org.

Glorian Publishing
PMB 192, 18645 SW Farmington Rd., Aloha OR 97007 USA
Phone: 212-501-6106 · Fax: 212-501-1676

VISIT US ONLINE AT:

gnosticbooks.org
gnosticteachings.org
gnosticradio.org
gnosticschool.org
gnosticstore.org
gnosticvideos.org

Books by Samael Aun Weor

Aquarian Message
Aztec Christic Magic
Beyond Death
Book of the Dead
Book of the Virgin of Carmen
Christ Consciousness
Christ Will
Christmas Message 1964-1965 (aka The Elimination of Satan's Tail/The Dissolution of the I)
Christmas Message 1966-1967 (aka The Buddha's Necklace)
Christmas Message 1967-1968 (aka The Doomed Aryan Race / The Solar Bodies)
Christmas Message 1968-1969 (aka The Gnostic Magic of the Runes)
Christmas Message 1969-1970 (aka My Return to Tibet / Cosmic Teachings of a Lama)
Christmas Message 1971-1972 (Parsifal Unveiled)
Christmas Message 1971-1972 (The Mystery of the Golden Blossom)
Christmas Message 1972-1973 (The Three Mountains)
Christmas Message 1973-1974 (Yes, There is a Hell, a Devil, and Karma)
Christmas Message 1977-1978 (Treatise of Occult Medicine and Practical Magic, revised)
Cosmic Ships
Didactic Self-knowledge (Collected Lectures)
Dream Yoga - Writings on Astral Travel and Dreams
Esoteric Course of Alchemical Kabbalah
Esoteric Course of Theurgy
Esoteric Treatise of Hermetic Astrology
Esoteric Treatise of Theurgy
Flying Saucers
For the Few
Fundamental Notions of Endocrinology and Criminology
Fundamentals of Gnostic Education
Gazing at the Mystery
Gnosis in the Twentieth Century
Gnostic Anthropology
Gnostic Catechism
Grand Gnostic Manifesto 1972

Grand Gnostic Manifesto of the Third Year of Aquarius
Great Rebellion
Great Supreme Universal Manifesto of the Gnostic Movement
Igneous Rose
Initiatic Path in the Arcana of Tarot and Kabbalah
Introduction to Gnosis
Kabbalah of the Mayan Mysteries
Logos, Mantra, Theurgy
Magnum Opus
Major Mysteries
Manual of Practical Magic
Matrimony, Divorce and Tantrism
Metallic Planets of Alchemy
Mountain of Juratena
Mysteries of Christic Esoterism
Mysteries of Life and Death
Mysteries of the Fire: Kundalini Yoga
Perfect Matrimony, or The Door to Enter into Initiation
Perfect Matrimony - Kindergarten
Pistis Sophia Unveiled
Platform of POSCLA
Power is in the Cross
Revolution of Beelzebub
Revolution of the Dialectic
Revolutionary Psychology
Secret Doctrine of Anahuac
Secret Notes of a Guru
Seven Words
Social Christ
Social Transformation of Humanity
Supreme Christmas Message 1965-1966 (The Science of Music)
Supreme Christmas Message 1967-1968
Treatise of Occult Medicine and Practical Magic
Treatise of Sexual Alchemy
Universal Charity
We'll Reach the One Thousand, But Not the Two Thousand
Yellow Book
Zodiacal Course

Visit gnosticbooks.org for more information.